The Arts of Fire

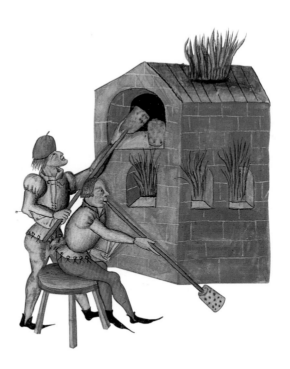

Viola

re mado · viol in olo decaniat~
colatum est oleum viol vel
fiat decoctio in duplici vascu
lo meli9 et decaquantur et
fiat colatura et coletur addit
recentes et sic dimittantur
per xv dies sic secundo et tercio
additur viol recentes vt ius
olatur Oleum istud optimi
est quo~ istor~ interius receptu
vt contra discursia color~ tocius
corp~ oll iunctio facta exteri9
vt contra calefactor~ epis · vncto
crud fcta sup tpa~ frote~ dol~ ex
cilior~ remouit · Virtutem habet
lenendi et humectandi infundi
et laxandi Viol ortite siue
vir~ herba sup aua apriēta ipriamo
tu vt Fomentu ex aqua decoctois
ip9 herbe s3 rede et fronte~ in acutis
febrib; somnu~ provocat s3 r9 viol
mane decaptur q rose artificus
cumueretur

Viola frigida est in i gradu
humidi in fine ipi sicc
pfluumu seruatur melius est
si si viridis anno renouetur et
ipsic viridibus fit zucca viol
sr9 viol mellis viol oleum
viol s3 ruius aut viol fit de
viridibus e ficcis s3 ex minus est
efficax Zucarium violaceum
fit eade~ mod quo et Rosaceo si
rupus viol sic fit Violarum
in aqua decaquantur et dimittat
in aqua per nocte~ et ex colatura
et zucaruo fiat sirupus s3 sic fit
melius si ex nure succo et zucco
fiat Oleum violaceum fiat

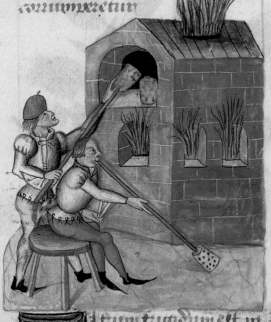

Vitru

ltum fundum est in i ·
i madusic in ii · Virtu
pter he~ sit et sablone excontioe

The Arts of Fire

ISLAMIC INFLUENCES ON GLASS AND CERAMICS
of the ITALIAN RENAISSANCE

Edited by Catherine Hess

With contributions by
Linda Komaroff and George Saliba

The J. Paul Getty Museum, Los Angeles

This publication is issued in
conjunction with the exhibition
*The Arts of Fire: Islamic Influences
on the Italian Renaissance,*
held at the J. Paul Getty Museum,
May 4 – September 5, 2004.

© 2004 J. Paul Getty Trust

Getty Publications
1200 Getty Center Drive, Suite 500
Los Angeles, California 90049-1682
www.getty.edu

Christopher Hudson, *Publisher*
Mark Greenberg, *Editor in Chief*

PROJECT STAFF
John Harris, *Editor*
Kathleen Preciado, *Manuscript Editor*
Jeffrey Cohen, *Designer*
Suzanne Watson, *Production Coordinator*
David Fuller, *Cartographer*

Typography by Diane Franco
Color separations by
Professional Graphics, Inc.,
Rockford, Illinois
Printed by CS Graphics, Singapore

Unless otherwise specified, all photo-
graphs are courtesy of the institution
owning the work illustrated.

Transliteration from Arabic has been
simplified throughout.

Library of Congress
Cataloging-in-Publication Data

The arts of fire : Islamic influences on glass
and ceramics of the Italian Renaissance /
edited by Catherine Hess with contributions
by Linda Komaroff and George Saliba.
 p. cm.
 Includes bibliographical references and
index.
 ISBN 0-89236-757-1 (hardcover)—
 ISBN 0-89236-758-X (pbk.)
 1. Glassware—Italy—Islamic influences.
2. Glassware, Renaissance—Italy.
3. Pottery, Italian—Islamic influences.
4. Pottery, Renaissance—Italy. 5. Art,
Islamic—Influence. I. Hess, Catherine,
1957– II. Komaroff, Linda, 1953–
III. Saliba, George.
 NK5152.A1A75 2004
 738'.0945'0904—dc22
 2003023717

Front cover: *Tazza* (detail). Egypt or Syria,
late thirteenth to early fourteenth century.
See pl. 4.

Back cover: Pilgrim flask. Italy (Murano),
late fifteenth or early sixteenth century. See
pl. 12.

Frontispiece: *Furnace and Glassblower*, 1458
(detail). From Dioscorides, *Tractatus de herbis*,
Ms. Lat. 993, 238r. Biblioteca Estense di
Modena. Photo: Foto Roncaglia, Modena.

Page vi: Hugo van der Goes (ca. 1420–
1482). *The Adoration of the Shepherds* from the
Portinari Altarpiece, 1476 (detail). Tempera
on wood, 253 × 304 cm (99⅝ × 119⅛ in.).
Florence, Galleria degli Uffizi, inv. 3191.
Photo: Eric Lessing/Art Resource, New York.
A Spanish ceramic jar and Venetian glass
beaker serve as vases.

Contents

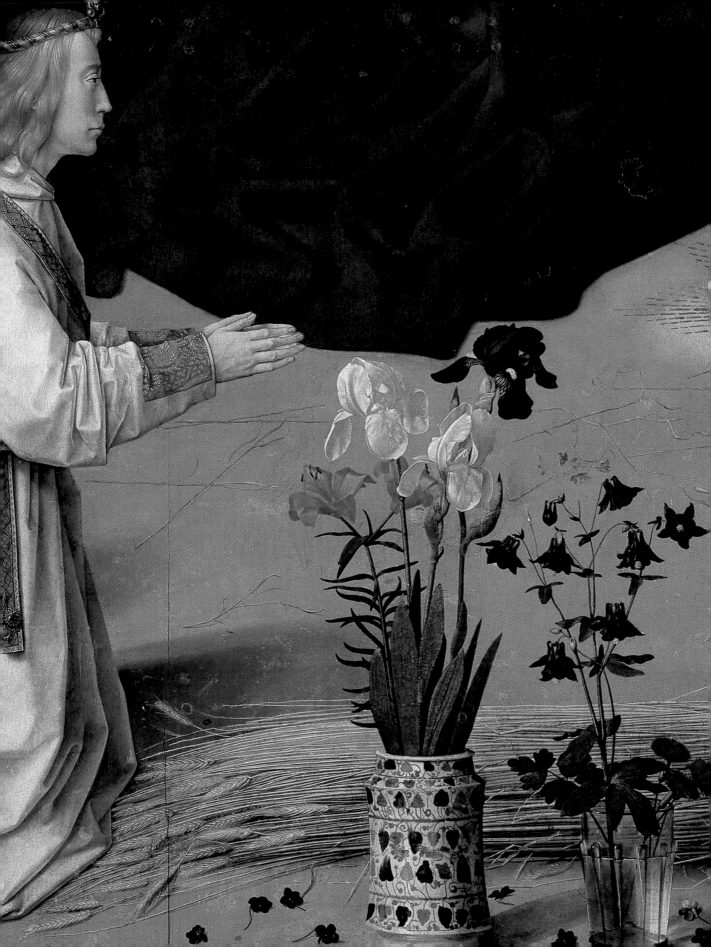

Foreword

Luxury glass and ceramics produced during the fifteenth and sixteenth centuries in Italy signify high points of Renaissance art production. Commonly known as cristallo and maiolica, these were groundbreaking art forms that established taste and became the envy of European courts and other collectors for the next three hundred years.

To this day, the visual appeal of these objects, at times stunningly beautiful and virtuosic, stimulates both the passion to collect them and the interest to study them. Since the late nineteenth century, research by collectors, curators, and scholars has helped to fill in the picture of Italian maiolica and glass production. Much of this research concentrates on placing these art forms within the Italian cultural and social context, and rightly so. But this artistic production would not have been possible without the technological and formal advances that arrived in Italy from outside the peninsula. *The Arts of Fire*, and the exhibition it accompanies, concentrates on the sometimes overlooked contributions that came to Northern Italian glassmakers and ceramists from the Islamic world.

The Getty's own collection of Italian ceramics and glass has been ably documented in recent collection catalogues. Now Catherine Hess, author of those earlier volumes and associate curator in the Department of Sculpture and Decorative Arts, has initiated an exploration of the Museum's objects from a new angle of vision: the complex influences, both technical and aesthetic, of Islamic glass and ceramics makers on their Italian counterparts. To flesh out this story she has borrowed important objects from two other museums: the Los Angeles County Museum of Art and the Metropolitan Museum of Art in New York. I am indebted to both institutions for their generosity and willingness to share these rare objects with us; the story told in *The Arts of Fire* would have been incomplete without them. My thanks go also to the two distinguished scholars who contributed to this catalogue: George Saliba from Columbia University and Linda Komaroff from the Los Angeles County Museum of Art. Their essays, along with Catherine Hess's historical introduction, show the vital role played by Islamic art and science in the shaping of this intriguing aspect of the Renaissance in Northern Italy.

At a time when relations between East and West are fraught, it is a pleasure to sponsor an exhibition and catalogue that demonstrate such rich and productive connections between very different cultures. I am grateful to Catherine Hess and her collaborators for reminding us of this important chapter in the history of ceramics and glass.

DEBORAH GRIBBON

Director, J. Paul Getty Museum
Vice President, J. Paul Getty Trust

Acknowledgments

THE IDEA FOR THE EXHIBITION
at the Getty Museum that served as impetus for
this book of essays began with a number of
conversations I had with Tarek Naga. My discus-
sions with Tarek—an Egyptian intellectual and
architect who is also a friend—were provocative
and valuable and I would like to thank him
first of all. Linda Komaroff, curator of Ancient
and Islamic Art at the Los Angeles County
Museum of Art and author of one of the essays
in this volume, provided critical help and encour-
agement from early on. Thanks to her generosity,
the Getty Museum was able to borrow many
splendid objects from LACMA's collection for
the exhibition. Without her help the exhibition,
like this volume, could hardly have taken the shape
it did. I am likewise grateful to the other indi-
viduals responsible for lending to the exhibition:
Martin Chapman and Dale Gluckman of the
Los Angeles County Museum of Art; Daniel
Walker, Stefano Carboni, Peter Barnet, and
Laurence Kanter of the Metropolitan Museum
of Art in New York; and Sunrider, Chen Art
Gallery. Each of the forty-two marvelous objects
in the exhibition is reproduced, several for
the first time, in the plate section of this book.

I am thankful to George Saliba, professor
of Arabic and Islamic Science at Columbia Uni-
versity, for his fascinating essay in this volume,
which helps broaden the scope of the material
presented here. Timothy Wilson, Keeper of

Western Art at the Ashmolean Museum, Oxford, read my essay and his inspired comments improved it immensely. If all specialists provided such civilized and insightful critique, the scholarly world would be a better place. Nancy Micklewright also read my essay, and her suggestions further improved the whole. Priscilla Soucek, professor of Islamic Art at the Institute of Fine Arts, New York, kindly read Dr. Komaroff's and Dr. Saliba's essays. Nassim Rossi, a graduate student at Columbia University, provided important help in shaping my text and tracking down bibliographic references.

Various members of Getty Publications — Ann Lucke, Mark Greenberg, Deenie Yudell, Karen Schmidt, John Harris, Suzanne Watson, Jeffrey Cohen, and Cecily Gardner — are responsible for producing a book as beautiful and cogent as this one. I am particularly indebted to John, Suzanne, and Jeffrey for their hard work and brilliant ideas. Kathleen Preciado edited the text and saved the authors from several embarrassments. The mistakes that remain are our own.

At the Getty Museum, curator of paintings Scott Schaefer and, in my department, Ellen South provided various types of support, all valuable. I am thankful to Quincy Houghton, head of exhibitions and public programs, for her help in shaping and focusing the exhibition. Deborah Gribbon, director of the Getty Museum, and William Griswold, associate director for collec-

tions, were supportive of both the exhibition and this book from the very beginning. Their encouragement was critical in bringing these projects to fruition and I am grateful for their help. Thanks also go to my friends Waleed Arafa and Kerem Takur for their helpful insights into the Islamic religion.

This book and its accompanying exhibition follow in the footsteps of Alan Caiger-Smith, potter and ceramics expert, whose research into the origins of tin-glaze and luster pottery was nothing less than groundbreaking. My debt to him is immense.

Finally, this volume is dedicated to the memory of Edward Said (1935–2003) for his passion, wisdom, and belief that art can transcend the differences between people.

CATHERINE HESS

Associate Curator, Department of Sculpture and Decorative Arts, J. Paul Getty Museum

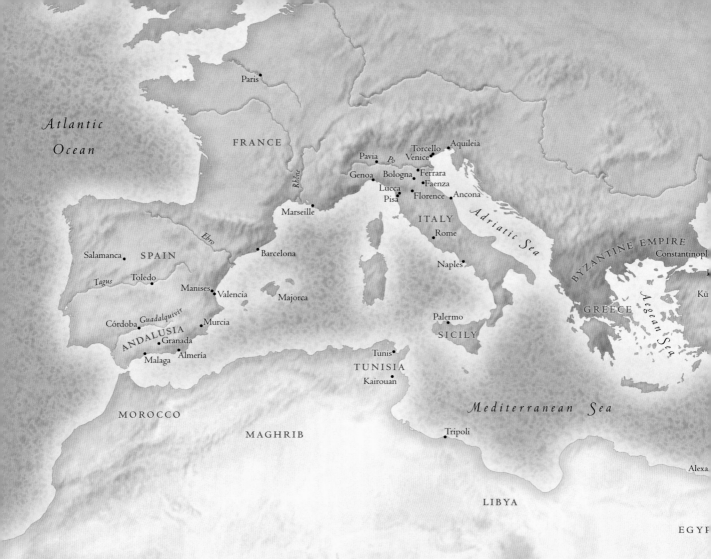

The Islamic World and Southern Europe

ca. A.D. 700-1800

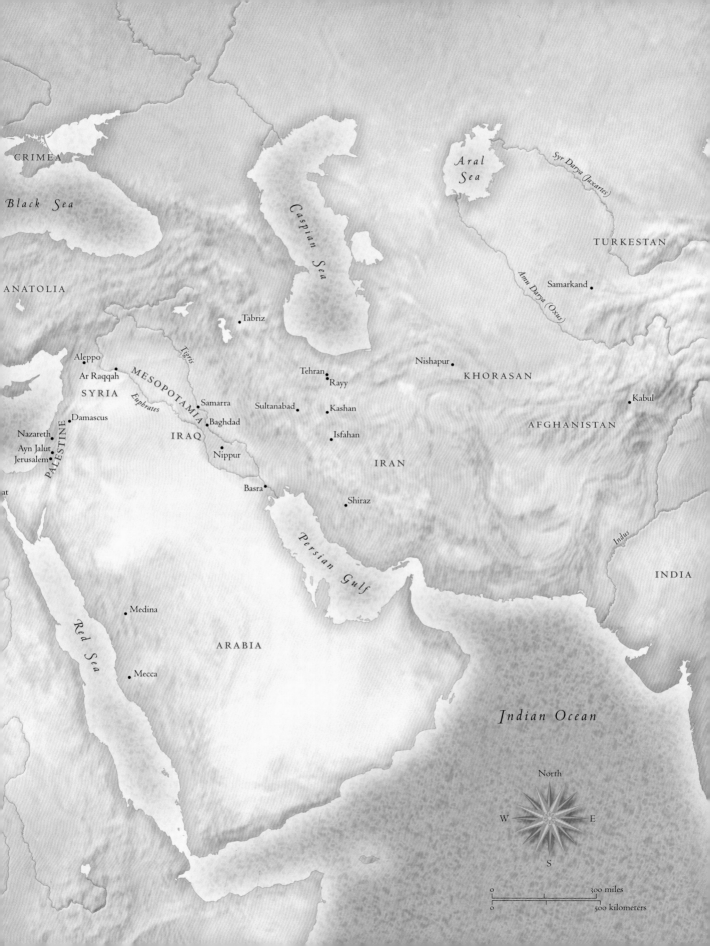

CRIMEA

Black Sea

ANATOLIA

Aleppo
Ar Raqqah
SYRIA

MESOPOTAMIA
Euphrates
Tigris

Damascus
Nazareth
Ayn Jalut
Jerusalem
PALESTINE

IRAQ

Samarra
Baghdad
Nippur

Basra

Red Sea

Medina

Mecca

ARABIA

Caspian Sea

*Aral
Sea*

Syr Darya (Jaxartes)

TURKESTAN

Amu Darya (Oxus)

Samarkand

Tabriz

Tehran
Rayy

Sultanabad
Kashan

Isfahan

Nishapur

KHORASAN

Kabul

AFGHANISTAN

IRAN

Shiraz

Persian Gulf

Indus

INDIA

Indian Ocean

North

W E

S

0 300 miles

0 500 kilometers

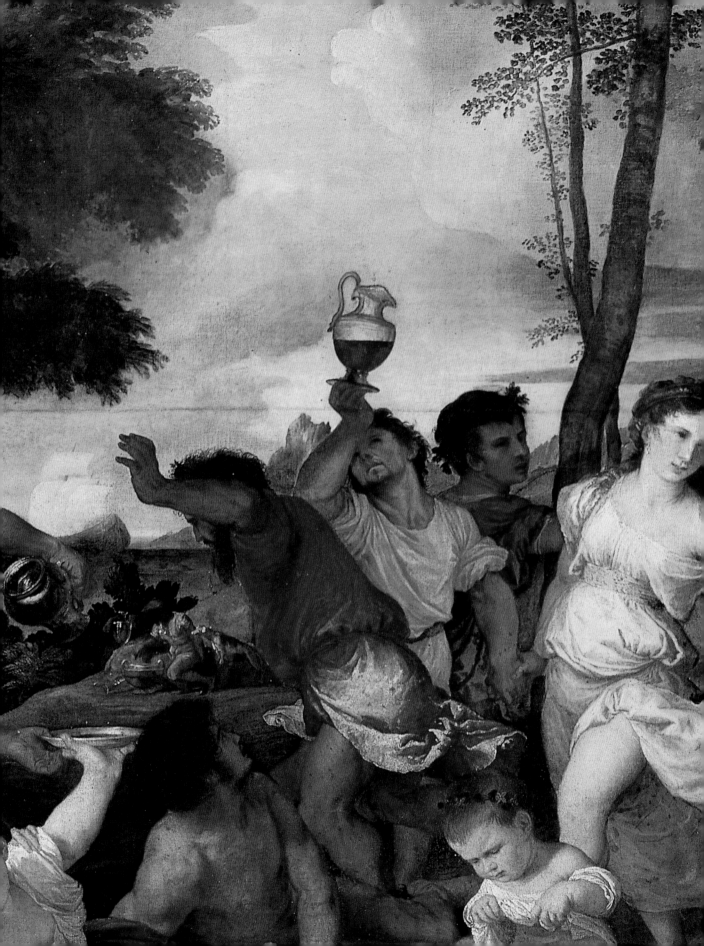

Brilliant Achievements: The Journey of Islamic Glass and Ceramics to Renaissance Italy

CATHERINE HESS

with the assistance of NASSIM ROSSI

Ars sine scientia nihil est.
— *Jean Mignot (ca. 1390)*

Abu'l-Qasim Muhammad ibn Abdallah ibn Abd al-Muttalib ibn Hashim was born around A.D. 570 in the trading town of Mecca on the Arabian Peninsula. According to Muslim belief, as an adult this man, known as Muhammad, began to receive messages from God. He shared these revelations with friends and family, who joined him in worship. The new religion was known as Islam, from the Arabic word for "submission," since its main precept was submission to the will of God, and its adherents were identified as Muslims. Muhammad's teachings, with their emphases on social reform and encompassing political, social, and religious principles, attracted many followers, and by the time of his death in 632 the religion of Islam dominated the Arabian Peninsula and became the basis of Arab unity, developing eventually into the Arab or Islamic Empire. Within one hundred years the religion of Islam expanded from Spain and North Africa, through the eastern Mediterranean, south through the Arabian Peninsula, north to the Caucasus, and east to beyond Kabul. The speed and ease with which the religion spread over such a great distance are nothing less than astonishing.[1]

Over subsequent generations great advances occurred in Islamic lands in mathematics, engineering, chemistry, literature, medicine, poetry, and astronomy — leading up to 1492, a familiar year in the Americas.

Opposite: Tiziano Vecelli, called Titian (ca. 1488–1576). *Bacchanal*, 1518–19 (detail). Oil on canvas, 175 × 193 cm (68⅞ × 76 in.). Madrid, Museo del Prado. Photo: Scala/Art Resource, New York.

What is not often remembered, however, is that while Columbus "sailed the ocean blue" for Ferdinand and Isabella, non-Christians, including Muslims and Jews, were persecuted and either forced to convert to Christianity or expelled from Spain in a move to consolidate that same monarchy.[2] The expansion of Christian Europe also marked the contraction and eventual extinction of the Islamic kingdom of Granada. In fact, the year 1492 signaled the decline of a golden age in Spain: the rich period that developed during the Islamic presence there.

Why did this golden age take place in Spain and elsewhere? In simple terms Islamic rule united, through language and religion, a vast area that retained the traditions of ancient civilizations. This unity facilitated communication, travel, and trade across a geographic expanse linking such far-flung areas as China and Spain. In addition, Islamic rulers established academies, schools, libraries, and observatories; patronized scientists; and supported research. Scientific advancements—in such areas as agriculture, luxury crafts, civil engineering, and medicine—helped produce the increasing material prosperity in Islamic cities.[3]

By the end of the fifteenth century "for the first time, Europeans had begun to acquire realistic images of the Muslim world," proof that they, specifically Italians, were engaged with and interested in Islamic society.[4] Pilgrimages to the Holy Land, diplomatic missions, trade, and cultural exchange all served to foster this awareness. For example, the arrival in Italy of visitors from the East—such as the Byzantine emperor John VIII Palaeologus (r. 1425–58), who attended the councils of Florence and Ferrara in 1438—and the return from the East of traveling Italians—such as the artists Benedetto Dei (1418–1492), who traveled to Africa and the Middle East in the 1460s as a political agent of the Medici, and Gentile Bellini (ca. 1429–1507) and Costanzo da Ferrara (ca. 1450–after 1524), who were invited to Istanbul in the 1470s and 1480s by Mehmed II (r. 1444–81, with interruptions)—brought individuals into contact with one another and helped develop relationships built on experience rather than rumor.

At this moment in Italy the Renaissance was fully under way. Giotto had been dead 150 years. Leonardo was about to paint his *Last Supper*, Michelangelo sculpt his *Pietà*, and Bramante embark on his reconstruction of Saint Peter's. In the field of decorative arts, where the distinction as "decorative" was not made at the time, Italian glass and ceramic production was reaching a level of sophistication and beauty unknown on the peninsula since antiquity.[5] The reasons for these developments are many and interrelated. Of these, the most straightforward and, perhaps, most decisive were the lessons learned from the Islamic world, without which these art forms would not have been possible.

Crafts arose and developed because an original creator transmits to a successor what he had created earlier. This successor examines it critically and adds to it as far as he possibly can. This process continues until the craft achieves perfection.

— *Abu'l-Faraj Abdallah (d. 1043/44)*[6]

Glass and ceramics have much in common. They are often united under the term "arts of fire" because of the heat that must be manipulated to create them. In an inverse sequence glass is melted and formed in a furnace, becoming rigid when it cools, while a soft piece of shaped clay hardens in a kiln. Glass and ceramics can also have very similar ingredients—silica, calcium, frits, and fluxes—confusing the precise definition of some glassy clay bodies, such as the so-called Egyptian faience and certain porcelains and frit pastes. In addition, glass and ceramics share an ancient history, explained in part by their function as jars for storage, vessels for dining, and beads and figurines of symbolic and ritual significance. Glass is a wonderfully sanitary material for food and drug storage — vessels made from it are watertight and easily washed—and pottery can be made likewise by being covered with a layer of glass, called glaze. Further, the technological development of glass and ceramic ornamentation for which these crafts became renowned art forms occurred in essentially the same place at the same time: in the Islamic Middle East between the eighth and twelfth centuries. For both glass and ceramics, this ornamentation highlighted the qualities of color and sparkle. Enameled glass and tin-glazed pottery accentuated color, while gilded glass and luster-painted pottery emphasized sparkle.

Glass

GLASSMAKERS OF ANCIENT ROME created spectacular luxury objects.[7] Some types of Roman glass—clear glass, mosaic glass, and glass decorated with gilding or enamel paint — reappeared in Venice a millennium after the end of the empire in the fifth century. A continuous history of glassmaking may have existed in Venice since ancient times. Roman glass dating to the fourth and fifth centuries has been found at Aquileia, and glass was produced on the Venetian island of Torcello as early as the seventh century.[8]

It is known, for instance, that glassblowing— the single most important innovation in the history of glass production, making possible the quick and easy manufacture of vessels in various useful shapes and sizes—was invented in Mesopotamia under Roman rule in the first century B.C.[9] Once invented, glassblowing (inflating molten glass at the end of a tube or blowpipe) became the preferred method of efficient

glass production (pls. 1–3). Whether other Roman practices of glass-making, such as the decorative techniques of enameling and gilding, persisted into later centuries or were developed independently and then brought to Venice is not known. It is likewise uncertain to what degree glassmakers from Byzantium or from Islamic lands were responsible for the transfer of these techniques to Venetian artisans. That parts of the Islamic Middle East especially important for glassmaking, Syria and Egypt, had been under Byzantine control before the Arab conquest in the seventh century complicates a clear understanding of the picture.

The earliest piece of postclassical enameled and gilded glass is a Byzantine object: a red bowl ornamented with figures from classical mythology probably dating to the tenth century and now in the San Marco Treasury, Venice (fig. 1). It is the only piece of luxury glass widely accepted as being of Byzantine manufacture.[10] Certainly there must have been many others and a fair amount of Byzantine common glass remains, including mosaic tessera, vessels, and windowpanes. Not only do documents describe an active Byzantine luxury glass industry,[11] but the first treatise on glassmaking, written in the thirteenth century, considers Byzantine practices.[12] It appears that the early Byzantine red-glass bowl reached Venice as booty after the fall of Constantinople just after the turn of the thirteenth century. Innocent III (pope, 1198–1216) ordered the crusade that led to the capture of Constantinople. Venice was asked to provide transport in exchange for payment and a division of spoils. The Venetian authorities also were interested in participating because the crusade gave them the opportunity to win territory. On April 13, 1204, Constantinople fell and underwent three days of looting and destruction. Many Byzantine artifacts, including Islamic glass in Byzantine mounts, were pillaged and carted off to western Europe, primarily to Venice.[13] One can imagine that the arrival of such objects spurred local interest in glass and glassmaking.

The so-called middle Byzantine era, the high point of Byzantine civilization, corresponds to a period of great flourishing of Islamic culture from the mid-ninth to the mid-thirteenth century. During this time contact between the Byzantine and Islamic worlds was inevitable if ambivalent. Despite episodic conflict, diplomatic ties fostered courtly gift giving, rivalry promoted artistic one-upmanship, political envoys engaged in commerce, and similar interests in luxury items and decorative themes were shared. All this served to circulate valued goods — textiles, metalwork, gems, and glass — between Constantinople and the Islamic communities in Spain, North Africa, Egypt, Syria, and Iraq. Since interest in promoting classical learning and science must have been shared among Byzantine and Islamic scholars, it would not be surprising if artisans were also eager to acquire technical advances pertaining to art production.[14]

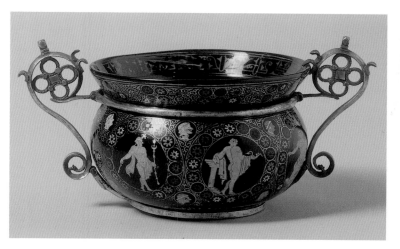

Figure 1
Glass bowl with mythological figures. Constantinople, probably tenth century.
Gilded and painted glass with silver gilt mounts and stones, H: 17 cm (6¹¹/₁₆ in.).
Venice, Treasury of San Marco, no. 109, 1325 inventory: V, no. 3.
Photo: Scala/Art Resource, New York.

Figure 2
"Aldrevandin" beaker. Probably Venice,
fourteenth century. Enameled glass,
H: 13 cm (5⅛ in.).
London, The British Museum, 76, 11-4, 3.
Photo: © The British Museum.

The first examples of fine Venetian enameled glass are vessels and vessel fragments, several signed with Italian names—Aldobrandini, Pietro, and Bartolomeo—and datable to the late thirteenth and early fourteenth centuries (fig. 2).[15] The method by which these beakers were shaped does not conform to the typical Islamic methods of manufacture, and the recipes for the glass and enamel differ from Islamic formulas. In fact, enamelers working in Venice came from areas formerly within the Byzantine Empire, where they would have been trained.[16] Nevertheless, although the earliest securely dated examples of Islamic glass decorated with gilding and enameling were made in the late twelfth and early thirteenth centuries, at least two hundred years after the Byzantine red-glass bowl in Venice was made, a tradition of painting on glass existed from the earliest years of Islamic rule in the East.[17] This tradition, involving the application of metallic oxides with a brush or quill pen, was developed in Egypt and Syria.[18]

It was, however, gilded and enameled Islamic glass of the late medieval period—produced under the Mamluks in Egypt and Syria, especially from the late thirteenth to the fourteenth century—that exerted the greatest influence on Venetian glass production (pls. 4–6). Indeed, this sumptuous glass is among the supreme achievements of Islamic glassmakers, and, not surprisingly, at its first appearance in Europe it created a sensation. Among the most splendid examples known today are beakers probably from Syria and datable from the late twelfth to the

Figure 3
"Luck of Edenhall" beaker.
Syria, mid-thirteenth century. Enameled and gilt glass.
H: 16 cm (6¼ in.). London, Victoria
and Albert Museum, C.1-1959. © V&A Images.

thirteenth century. Crusaders possibly brought these to Europe very soon after they were made. Several such beakers, such as the so-called "Luck of Edenhall," were supplied with European mounts or leather cases, which have helped preserve them in the eight hundred years since their manufacture (fig. 3).[19]

Glass was also imported along with other valuable merchandise.[20] Fourteenth-century archival sources tell us that glass *"di Dommascho"* was arriving in Venice and Florence and that Venice served as a transshipment point for glass lamps *"di Domascho."*[21] Since commercial scribes were probably not glass connoisseurs, the precise meaning of the description "of [or from] Damascus" is unclear. The fortunate discoveries of documents tracking individual objects illustrate the difficulties resulting from lax terminology. In one Italian invoice, a group of ceramics is referred to as *"porcellane domaschine"* and in a financial report describing the same objects, they appear simply as *"porcellane."* Was this Chinese porcelain that arrived via Damascus, a porcelainlike Syrian object, or some kind of blue-and-white pot from the Islamic Middle East?[22]

Not only objects, but also actual practices traveled from east to west. A fifteenth-century manuscript in Bologna provides evidence that glass enameling in Venice was based on processes used in Islamic lands.[23] As further confirmation of contact with the Islamic world, from the thirteenth century on, about the time that Venetian glassmakers were organized in the guild of the *fiolarii* (bottle makers), most raw materials necessary for glassmaking were imported into Venice from the Levant.[24] Byzantine glassmakers were working in Venice by the thirteenth century and it seems likely that Islamic craftsmen were as well, particularly after the destruction in 1401 of Damascus and Aleppo, major Syrian centers of glass production, by the Turco-Mongol conqueror Timur (1336–1405), known in the West as Tamerlane.[25] Although we do not know precisely how and when this transference began, it is clear that some combination of objects arriving from the East, creating local taste and providing examples to copy, and information gleaned from the objects' makers brought the valued techniques of glass enameling and gilding to Venice.

Ceramics

For ceramics the story is similar, if older. Mesopotamia was an area of great development of the ceramics medium, partly because of the area's geographic particularities between the Tigris and Euphrates rivers. This fluvial region was annually flooded and replenished with silt, making clay handy and abundant. Clay use there became widespread thousands of years before Roman rule and served to create architecture, pottery, sculpture, and even stamped labels identifying the ownership or contents of a container. This labeling practice, whereby simple tools were impressed in soft clay, led, in 3000 B.C., to cuneiform marking, an intellectual achievement that amounted to nothing less than the invention of writing.[26]

Glazed pottery became an art form in northern Mesopotamia under the Assyrians around 1000 B.C. These glazes were transparent—tinted mainly blue, yellow, or green—and served at least as much to seal the porous clay body as to ornament it. From the sixth to the fourth century B.C. pottery with glazes that obscured the clay body was produced in this area, specifically in Iraq around Nippur and other sites. This opaque-glaze ware continued in production until the end of the Sasanian dynasty (224–651), the threshold of the Islamic era. Scientists have found that crystals, bubbles, and undissolved quartz caused the density of these rudimentary glazes.[27] Under Islamic rule an important discovery was made. By adding tin oxide to a transparent glaze, potters in Iraq and Syria found that they could create an opaque, white, and non-runny ground for colorfully painted ornamentation (pl. 14).[28] This discovery established ceramics as a painterly medium and decisively changed its history.

Technical studies tell us that tin had been used under the Romans to create opaque glass as early as the second century A.D.[29] The use of tin opacification for ceramic glazes must have resulted from knowledge of the technique that remained in the formerly Roman areas of Iran and Iraq coupled with the stimulus supplied by Islamic rule. In the eighth and then in the ninth century the capital of the Islamic world was located first in Damascus and then in Baghdad. These areas were the wealthiest in an enormous empire, united under a series of caliphs, the civil and religious leaders of the Muslim state. In addition, it was a policy of the caliphate to promote knowledge,[30] whether from classical texts, from other parts of the empire, or from empirical research, such as that concerned with technical processes. This interest in science, coupled with the caliphate's wealth—which stimulated a taste for fine things—led to technical achievements in the production of art.

Around this time porcelain—that most prized of all ceramic ware for its translucency, whiteness, fine grain, and strength (making possible the creation of elegant thin-walled vessels)—was created in China during the Tang dynasty (618–907) and began circulating toward the eastern Mediterranean. That some early Islamic whitewares copy Chinese shapes confirms that the development of tin glaze was an attempt to imitate the prized import.[31] A document of circa 1059 records the diplomatic gift of the late eighth to the early ninth century of more than two thousand pieces of porcelain sent by the governor of Khorasan to Harun al-Rashid (r. 786–809) of the Abbasid dynasty (750–1250),[32] whose interest in the arts resulted in the creation of art and luxury, memorialized in the *Thousand and One Nights* (see Komaroff's essay in this volume, p. 40).[33] This importation must have stimulated market demand, prompting potters to copy techniques and styles. For the highly admired and coveted whiteware porcelain of the Tang and later Song dynasty (960–1279), however, local artisans were capable of copying only the appearance, not the technique. In fact, nearly another thousand years transpired before true porcelain was successfully produced outside China in 1707 at the Meissen factory in Saxony.[34] By adding tin oxide to the glaze of their earthenware, Iraqi potters, soon after the year 800, succeeded in producing the first whiteware ceramics to be made outside the Far East.[35]

Porcelain from China, with its brilliant and thin white body and glassy smoothness, was also greatly valued abroad for a later development: blue-and-white decoration (pl. 37). Blue decoration from cobalt oxide had been used on Chinese earthenware of the Tang dynasty. On Chinese porcelain, however, good-quality blue-and-white decoration was first produced in the second quarter of the fourteenth century and exported to Islamic areas soon after. It seems that Chinese potters produced such porcelain primarily for export rather than for local consumption.[36] One scholar maintains that blue-and-white porcelain was adopted "in response

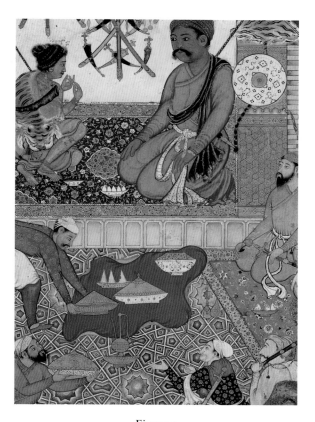

Figure 4
A Prince Receives a Holy Man, leaf from the *Dastan-i Amir Hamza*.
India (Mughal), ca. 1570 (detail). Colors on cloth, mounted on paper,
70.8 × 54.9 cm (27⅞ × 21⅝ in.). New York, The Metropolitan
Museum of Art, Rogers Fund, 1924, 24.48.1.
Photo: © 2001 The Metropolitan Museum of Art.

Blue-and-white porcelain dishes are used to present food
in this elegant Mughal reception scene.

to new Mongol and Middle Eastern export taste for more obvious ornamentation"(fig. 4).[37] Other evidence of this early market in blue-and-white porcelain includes a chronicle of the first decades of the fifteenth century that tells us Chinese "blue porcelain" (almost certainly blue-and-white) was taken to Mecca and other parts of the Middle East on expeditions sent by the Ming dynasty emperor Yongle (r. 1403–24).[38] In addition, the great collections of Chinese porcelain that reached Turkey —probably brought there as loot after the early-sixteenth-century Ottoman conquest of Egypt and Syria— include fourteenth- and fifteenth-century porcelain that possibly had been in Middle Eastern collections since soon after its manufacture.[39]

To create blue-and-white ornamentation on porcelain, an under-glaze is used whereby the cobalt pigment is painted on the ceramic body and then fired under a clear glaze that acts like a varnish. Once again, potters in the Islamic Middle East first developed this procedure. The technique was used for twelfth-century ceramics from Syria and Iran and then, more than one hundred years later, on Chinese porcelain. Without a protective layer, cobalt, a strong colorant, blurs on the ceramic surface, and cobalt decoration on Chinese ceramics of the Tang dynasty shows this effect.[40] As further confirmation of these long-distance dealings, even though China had its own sources of cobalt, scientific examinations suggest that the type of cobalt used on early Chinese ceramics was imported from the Middle East, where it had been used to decorate ancient Egyptian glass and Assyrian pottery. It seems that Tang potters were unaware of their local supply and sought out sources in Iran, which were described by the Persian craftsman Abu'l-Qasim, whose treatise on pottery of 1301 mentions not only the source of the mineral near Kashan but also its preparation for ceramic decoration.[41]

At about the same time that Iraqi potters began using a tin glaze to create their own porcelainlike whitewares in the eighth century, they also began applying luster decoration to their ceramics. A sort of "poor-man's" gilding, the difficult and temperamental technique of luster manufacture took many years to perfect. To produce luster, metal compounds are applied onto the surface of a pot's already fired and usually tin-based glaze, which is then submitted to a reduction firing. In such a heating process the fire is suppressed by restricting the air supply or by adding wet fuel to the kiln. The resulting carbon monoxide seeks out oxygen, which it finds in the metallic compounds, chemically converting them into an iridescent film. Iraqi potters seem to have adapted the luster technique from glassmakers. As mentioned earlier, Egyptian and Syrian glassmakers painted their glass vessels with silver and copper lusters from as early as the eighth century (pl. 15).[42] Soon after, the technique was used on pottery (pl. 16). For more than a century luster-painted ceramics seem to have been made only around Baghdad, from whence they were shipped to the far reaches of Islamic society. The tiles sent to ornament the Great Mosque of Kairouan, Tunisia (862–63)—the capital of the Islamic Aghlabid dynasty (800–909)—can still be seen today in their original setting.[43] From the tenth to the twelfth century the production of luster on both pottery and glass spread from the Middle East (pls. 17–18). As twelfth-century artisans mastered glass gilding, to produce an even more glittering effect than luster, the practice of glass luster died out.[44]

Also in the ninth-century East—in Iran, Iraq, and parts of Central Asia—potters began to achieve chromatic ornament on their ceramics by scratching through a top layer of light-colored slip to reveal a dark clay body beneath, a technique thought to originate in Tang China.[45] For

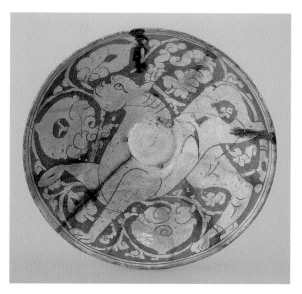

Figure 5
Bowl. Iran, probably eastern Mediterranean,
eleventh century. Incised slipware (earthenware),
DIAM: 21.8 cm (8⁹⁄₁₆ in.).
London, Nasser D. Khalili Collection, POT704.

Figure 6
The Virgin with Saints Roch and Sebastian.
Perhaps Italy, Venice, ca. 1500–1510 (?). Incised slipware
(earthenware), 33.7 × 27.8 cm (33¼ × 11 in.).
Cambridge, Fitzwilliam Museum, EC.1-1938.
Photo: © The Fitzwilliam Museum.

these wares, the costly tin glaze with its capability to produce clearly
painted decoration was not needed. Instead a clear lead glaze was used
to protect the friable surface. The technique reached Italy, where it
was copied and called sgraffito (Italian, "scratched") (figs. 5–6). These
incised slipwares could have arrived as souvenirs in the hands of pilgrims
to the Holy Land or as trade items. Potters migrating from the East
could have also brought the technique with them.[46] As with glass, these
artisans might have been from Byzantium or traveled to Italy via
Byzantium.[47] At any rate, Byzantine examples often copy earlier Islamic
models. For example, the decoration can include animals and activities
of the hunt, a favored pastime of Islamic court life symbolizing princely
values and authority.[48]

Evidence of the importation of Islamic ceramics into Italy is pro-
vided by the Italian practice of embedding dishes or basins, called *bacini*,
into the brick walls of churches and other buildings—found in and
around such cities as Milan, Pavia, Bologna, Florence, Lucca, Rome, and,

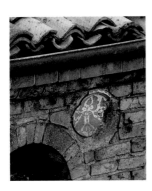

Figure 7
Plate with facing birds.
Egypt, eleventh–twelfth
century. Lusterware,
inset into wall of the lantern
of San Teodoro, Pavia.

especially, Pisa—in an effort to embellish the architecture colorfully in a similar but less expensive manner than by insetting mosaics or stone (fig. 7).[49] These *bacini* represent sgraffito as well as lead-glazed, tin-glazed, and luster-painted production and date from the eleventh to the thirteenth century. They are among the earliest examples of such pottery to arrive in Italy. Since most of these churches have documented architectural programs, Islamic *bacini* are further valuable in establishing dates for comparable Islamic pieces, a field of study notorious for its lack of dating benchmarks. Most of these *bacini* were made in Tunisia, Sicily, or Spain, with a smaller number from Fatimid Egypt or Syria.[50] The very similar, almost identical, examples from Tunisia and Sicily testify to the close contact between these places a mere hundred miles from each other at their closest points. Indeed, the same potters could have worked in both locations.

While incised slipware was traveling other routes, the ceramic techniques of tin glazing and luster painting reached southern Spain (Almería, Murcia, and Málaga) by way of Berber and Arab settlements across the Maghrib (the western part of North Africa bordering the Mediterranean) as well as, it appears, directly from the Islamic Middle East.[51] Not only techniques but also much of the early Spanish decorative repertory originated in the Middle East, especially Egypt, suggesting the presence of Egyptians among Spanish potters. Indeed, a Córdoban doctor records that potters from the "East" brought techniques of manufacture with them to Andalusia.[52] Although objects can inspire local interest and influence styles, actual practitioners must have taught the techniques since a full understanding of the vicissitudes of the procedure, especially for lusterware, was critical.

Tin-glazed pottery was produced by roughly A.D. 1000 in Spain, with luster production appearing later, by the early thirteenth century.[53] Murcia and, to a lesser degree, Almería were the most important lusterware centers in the thirteenth century, and both sponsored active trade relations with the ports of Pisa and Genoa.[54] By the early fourteenth century Arab travelers to Spain extol the beauty of "golden pottery" from Málaga.[55] This town was the main port of the Nasrid dynasty, the last of the Muslim dynasties in Spain, established in 1238 and centered in Granada. Málaga became so famous for these ceramics that its name became associated with Spanish lusterware in general. Documents of the fourteenth, fifteenth, and sixteenth centuries list this pottery as "*obra de málequa*" or "*de málicha*" (Málaga ware) whether or not it was made in Málaga.[56]

In the fourteenth century the ceramic industry in Spain shifted location in response to economic and political demands. When the Nasrid kingdom began to falter because of internal struggles and pressure from a newly united Christian Spain, potters migrated north to areas outside the Islamic sphere, such as Barcelona and, especially, Valencia (pls. 19–20).

Pottery had been made in the Valencian region since at least Roman times, suggesting that there was good clay in the vicinity. When Muslim potters became active in the area, they settled primarily in the town of Manises. The earliest reference to this activity is a document of 1342 that mentions the production of *"obra de málequa"* (lusterware) in Manises.[57] The virtually indistinguishable Málaga ware and early Manises pottery suggest that these potters emigrated directly from the Nasrid port town. The potters may have chosen Manises, at least in part, because they were encouraged to do so by members of an important local family, the Boil, entrepreneurial landowners with connections to the Aragonese crown. In 1372 Pedro Boil, lord of Manises, requested that King Peter IV (r. 1336–87) grant him a concession for all business involving ceramics in his town.[58]

As with enameling and gilding on glass, precisely how the techniques of tin glaze and luster on ceramics reached Italy is unclear. The importation of objects, which would have stimulated taste and supplied examples to copy, led to stylistic relationships. Artisans, however, must have provided the technical expertise, given the complexities of the procedures. The identity of these individuals is not known, although one can trace where and when the techniques "traveled" around the Mediterranean—appearing first in one place and then another along a general route—until they reached Italy and later spread north of the Alps. Remarkably, the timetable for both glass and ceramics is essentially the same. For glass, this path originates east of the Mediterranean around the ninth century and the techniques gather improvements from various points in the Islamic Middle East before reaching Venice around the thirteenth century via Byzantium. For ceramics, the starting point is the same and occurs around the same time but the path appears to take two directions: one to North Africa and then to Italy in the twelfth century by way of Sicily or to one of the peninsula's more northern ports; the other across North Africa or directly from the Islamic Middle East to Spain and then to Italy.

The early importation of ceramics from the Islamic world—from the East as well as from Spain—mainly comprised *bacini*, arriving as early as the eleventh century. Around 1150, almost certainly in response to this importation, Italians produced a few isolated examples of their first tin-glazed ceramics: in Pavia a band of tin-glazed bricks on the Torre Comune and tin-glazed *bacini* on the nearby church of San Lanfranco.[59] One hundred years passed, however, before tin glazing became widespread in Italy. Two basic types of early tin-glazed ceramics coexisted in Italy from the mid-thirteenth century, if not slightly earlier, and appear to have originated from different sources. One comprises jugs, plates, and basins painted in a simple palette of manganese brown and copper green with the later addition of some yellow and blue.[60] This type, often called

archaic maiolica, seems to predominate in central and northern Italy. The second type, often called proto-maiolica, mainly includes plates decorated in a more varied palette and seems localized south of Rome and in Sicily.[61] Within one generation the production of tin-glazed ceramics was standard practice in workshops throughout the Italian peninsula.

The luster technique was achieved later, in the second half of the fifteenth century. The primary centers of luster-painted ceramics in Italy were Deruta and Gubbio, although evidence shows that potters from other centers—such as Cafaggiolo, Faenza, and Naples—were capable of mastering the tricky process.[62] Although Deruta had been a pottery town since the end of the thirteenth century, the earliest dated piece of Italian lusterware is a relief plaque inscribed with the date July 14, 1501.[63] Whether this plaque was made in Deruta or not, other evidence indicates that luster was being produced there long before, around the mid-fifteenth century. A luster-painted Deruta jar in the Louvre conforms to a shape and style of decoration in fashion from 1460 to 1490[64] and could not have been produced much beyond those dates.[65] In addition, a statute of 1465 mentions that city streets were being blocked by juniper branches, a kiln fuel used only in reduction firings to produce luster.[66] Deruta was known for a copper-oxide luster and a brassy, straw-colored sheen, whereas Gubbio, less than thirty miles away as the crow flies, specialized in a slightly later silver-oxide luster and a more golden reddish gloss (pls. 21–22). The luster process must have been one of those secrets that potters kept "hidden from [even] their own sons, and then, knowing themselves to be on the point of death, among other goods they leave behind, they summon their oldest and wisest son, and reveal to him the secret."[67]

Arguably the most important stimulus to the nascent art of ceramic production in Italy was the contact with Spanish wares. Archaeological evidence suggests that Spanish ceramics—tableware as well as *bacini*—had been imported into Italy since the tenth and eleventh centuries.[68] Later, the large numbers of Valencian ceramics commissioned by Florentine families in the second half of the fifteenth century make clear that this type of object was especially prized (fig. 8).[69] Why this is so probably has as much to do with mercantile associations as it does with fashion. Active trade, some passing through Majorca, a transshipment point to docks throughout the Mediterranean, linked Manises, the port serving Valencia, and Pisa, the port serving Florence. By the fourteenth century Valencia and Florence were among the few European towns to claim an exchange, an organized center where commodities were traded.[70] Although other valued ceramics had arrived in Italy earlier —such as Chinese porcelain and Islamic fritware—the more general influx of Spanish lusterware in the fourteenth and fifteenth centuries helped transform ceramics into a true luxury commodity in Europe.

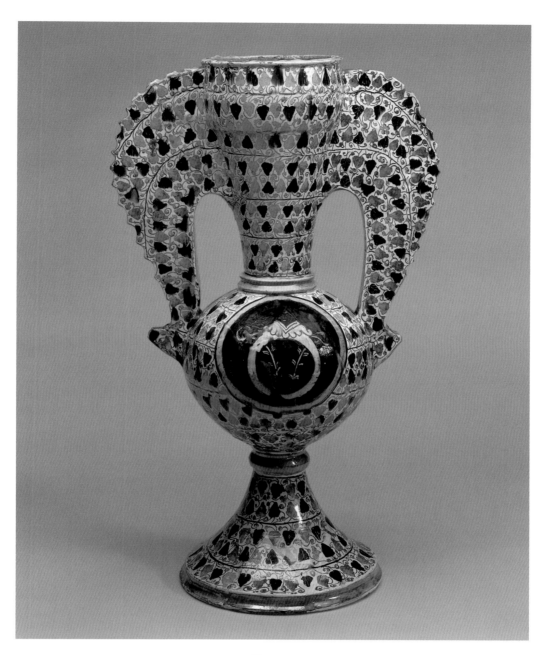

Figure 8
Jar with wing handles. Probably Spain, Manises, after 1465.
Tin-glazed earthenware, H: 57 cm (22½ in.).
London, The British Museum, Godman Bequest, G619.
Photo: © The British Museum.

The image in the center of this jar—a diamond ring and three ostrich feathers—
is a device of Florence's Medici family.

The term that has come to signify Italian Renaissance tin-glazed earthenware—"maiolica"—derives either from the Spanish phrase *obra de málequa* or from the distribution entrepôt of Majorca. It initially referred solely to imported luster products and only much later described the famous Italian production. As late as 1557 Cipriano Piccolpasso (1524–1579) used the term in this way in his famous manuscript treatise on pottery making.[71] In like fashion, the term used for European products emulating maiolica—faience—derives from the name of an Italian town, Faenza, much of whose late-sixteenth- and seventeenth-century pottery was exported north of the Alps, where it became very popular.[72] The naming of an object type after a place known for its manufacture was not new, as the Persian name for ceramic tile is *kashi* or *kashani* and probably derives from Kashan, Iran's main center for lusterware production by the second half of the twelfth century.

After becoming skilled in the techniques of tin glaze and luster, Italian potters developed their medium to satisfy local taste and market demands. Early pigments—such as copper green and manganese brown—were so-called solution colorants that dissolved and spread into the glaze ground when fired. By 1450 potters had developed colors that had insoluble pigment particles and a binder component to keep the colors stable during firing. This development gave ceramic painters precise control of the pigments, making possible the rendering of clear and, at the same time, subtly modeled images in often complex compositions.[73] In addition, around that same time, potters began using a lead-silicate top glaze —*coperta* or *vetrina*— to smooth out the irregular pigment layer and form a bright, reflective, and protective surface. As in underglaze painting, this top layer also helped hold the painted decoration in place and keep it from running in the kiln. Carefully prepared pigments and glazes were critical for the successful outcome of this process, which made possible the firing of many dozens of elaborately decorated objects in the kiln at the same time and at the same temperature.[74] Such manufacturing efficiencies must have proved beneficial, if not decisive, for the market. Indeed, the success of the Italian maiolica industry by the end of the fifteenth century was enormous, eclipsing Spanish production and establishing a new type of painterly ceramic ware that dominated Europe until the advent of porcelain three hundred years later.

Around the mid-fifteenth century the Venetian glass industry achieved similar success, largely determined by the development of various types of luxury glass, the most important of which was an especially clear and colorless glass called *cristallo* after the rock crystal that it evoked. Refinements in glassmaking technology made possible the production of *cristallo* (pls. 8, 12–13). These refinements included elaborate procedures to purify the glass mixture, the use of a decolorizer,[75] and the continual stirring of the molten glass while maintaining it at the highest possible

temperature.[76] Glass became an important and prestigious Venetian export, and the restrictions imposed on the industry reflect its importance to the Republic.[77]

Early on, the forms and decoration of Italian glass and maiolica betrayed their Islamic origin. Produced in both materials, common cylindrical jars—*albarelli* (pls. 26, 32–36)—and canteens—pilgrim flasks (pls. 12–13, 23, 42)—are forms that came to Italy by way of the Middle East. Italian glass ewers with attenuated and elegantly curving spouts (pl. 10) seem to have copied earlier Middle Eastern or Chinese examples.[78] In addition, Islamic tiles influenced the Italian versions, both in the painted ornament and in the geometric patterning of the tile arrangement. The incorporation of Islamic tiles as architectural elements by the ninth century—for interior and exterior surfaces of secular and nonsecular buildings—represents the most sophisticated use of tilework up to that time. Probably some combination of the love of geometric patterning, the development of techniques to produce bright and clear glazed ornament, the importance of architectural settings for worship and learning, and a hot, dry climate for which cool and easily cleaned surfaces were a benefit led to this remarkable production. Kashan in Iran was the most important production center for Islamic tiles during the first quarter of the thirteenth century and then again, after the Mongol invasions, in the second half of that century, during the Ilkhanid dynasty (1256–1353).[79] Syria, Spain, North Africa, and, in the sixteenth century, Ottoman Turkey were the most important areas for tilework in the Islamic world. Tile production comprised four basic types: single tiles, composite-tile panels, tile mosaics, and tiled architectural elements such as prayer niches (mihrabs). Most prominent in fifteenth- and sixteenth-century Italy were the single tiles often called *a cellula autonoma* (tiles whose images were "autonomous" and did not link with neighboring tiles to complete the picture). These were arranged in such patterns as hexagons around a central square and stars interlocking with crosses.[80]

Dense surface ornament emphasizing geometric patterns—knotwork, diapered scales, arabesques, rosettes or medallions, shallow foliage, and Arabic script—became popular on early Italian vessels and dishes (pls. 10, 12, 21–22, 26, 34–35). A decorative type referred to as a contour panel, whereby figural elements are given an approximate outlined border and set against a contrasting background, was also adopted from Islamic crafts, probably ceramics. It appears that textiles—highly prized and easily transported (folded and stacked without the risk of breakage)—played a particularly large role in circulating motifs (pls. 11, 27, 30). Textiles from the Islamic world may well have brought to Italian ceramics such widespread early motifs as the palmette and paired animals (pls. 28, 31). The palmette takes many forms. It can resemble the lotus, from which it is thought to derive, or a more elaborate vegetal or fruitlike form that,

by 1450, can take the distinct shape of an artichoke or pomegranate. Various palmette motifs were adopted for maiolica ornament around 1500 but became particularly widespread on sixteenth-century and later Italian brocades, cut velvets, and damasks (whose name indicates their presumed Eastern origin in Damascus).[81] The paired-animal motif is of ancient origin. Repeats of facing or addorsed animals may have become prevalent on textiles from early on because the complicated system of drawloom harnesses—used to render the woven image by raising and lowering warp threads—favored symmetrical patterns of regular outlines. Weavers could, therefore, create, without too much trouble, a visually interesting and figured textile pattern by simply repeating a nonsymmetrical image that had been flopped back to front.

The "Oriental" influence on early Italian maiolica was recognized from the first years of maiolica studies.[82] One pioneer, Gaetano Ballardini (1878–1953), ventured to make the field comprehensible in the 1930s by establishing typological and chronological categories that remain useful today.[83] His "Severe Style," spanning the whole of the fifteenth century, encompasses several types (such as the evocatively named "Italo-Moresque") that codify and clarify links with the Islamic world. Although most stylistic influences traveled east to west,[84] there is occasional evidence of Italian shapes and ornament influencing Eastern pottery.[85] Much has yet to be understood of such stylistic transferences. To what degree does the adoption in Italy of foreign ornament indicate, for example, a preference for "exotic" styles (or, at least, those styles traditionally associated with the imported crafts), the presence of foreign craftsmen in Italian workshops, or the tendency of Italians to copy these new imports before they felt confident enough to develop their own idiom?

As the fifteenth century progressed, most Italian glass and ceramic artists began to favor more typically Italian ornamentation, including coats of arms, figures, trophies, classicizing busts, and whole narrative scenes (pls. 13, 21, 23, 36, 39), the likes of which were already well established in panel, fresco, and oil painting. As in narrative painting, ceramic subjects drew from such sources as Roman history, the Bible, and mythology. Maiolica painters adopted current pictorial techniques—chiaroscuro, volumetric modeling, linear perspective—with the aim of rendering naturalistic figures in illusionistic space.

With glass, the fashion for this kind of decoration did not endure. Perhaps the vivid colorism of such scenes was deemed unsuitable for delicate glassware, the prized clarity of which had been hard won. Moreover, the undulating surfaces of wine vessels may not have easily lent themselves to pictorial scenes. In contrast, northern drinkers preferred tall, cylindrical vessels for their beer. Such vessels with their large expanses of glass may have spurred glassmakers north of the Alps to develop elaborate enamel decoration into a characteristic art form. Rather than

featuring enamel painting, sixteenth-century Venetian glass began to display embellishments that played on the delicacy of the medium, such as the distinctly nonpictorial and noncoloristic techniques of diamond-point engraving, filigree glass, and ice glass. Painters on pottery, however, specialized in narrative scenes. Starting around 1500 the so-called *istoriato* (Italian, "storytelling") maiolica was a specialty of such central Italian towns as Pesaro, Deruta, and, especially, Faenza. By 1525 Urbino and neighboring Castel Durante had become famous for their narrative ceramics, and some individuals responsible for this production—Francesco Xanto Avelli (ca. 1487–ca. 1542), Orazio Fontana (1510–1571), Nicola da Urbino (ca. 1480–1537/38), and Guido Durantino (fl. 1520–76)—distinguished themselves as masters of their art. Given the technical exigencies of their medium, many painters made extensive use of stencils to copy figures or whole scenes from prints or drawings. Apparently the market could only sustain the cost of painting ceramic compositions, not of inventing them.[86]

By the mid-fifteenth century porcelain and porcelainlike objects from the East are documented in Italian collections, sometimes in great number.[87] The rarity and preciousness of such ceramics increased the desire to create a similar product locally. Indeed, one decorative impulse shared by Italian Renaissance glass and ceramic artists was the desire to re-create porcelain. A type of glass common around 1500 was *lattimo*, so-called because of the *latte* (Italian, "milk") after which it was named. Milky white, glassy, and translucent, *lattimo* glass resembled porcelain so much that it was used to make a *porcellana contrefacta* (counterfeit porcelain) in late-fifteenth- and early-sixteenth-century Venice.[88] In 1519 Alfonso d'Este I (1486–1534), duke of Ferrara, ordered the purchase of two pieces of *porcellana ficta* (fake porcelain) that must have been glass.[89]

Porcelainlike maiolica (*alla porcellana*) was produced by about 1500, although it was never intended to serve as a substitute for porcelain.[90] A specialty of Cafaggiolo outside Florence, Venice, and Faenza, this maiolica combines scrolling foliage of Eastern derivation with Italian trophies and scrolls, all rendered in blue and white (pl. 39). Italians finally were successful in creating a kind of porcelain under the encouragement of Francesco I (1541–1587) and Ferdinand I de' Medici (1549–1609), grand dukes of Tuscany. Francesco had established a workshop to foster the creation of sought-after art forms, such as tapestries, hard-stone carvings, and porcelains, and his brother Ferdinand took over the enterprise on his death in 1587 (pl. 42). In 1575 the Venetian ambassador to Florence wrote that Francesco had rediscovered the method of making porcelain and that a craftsman from the East—alternately called a "Levantine" and "a Greek who had traveled to the Indies"—had helped teach the process.[91] The production of this so-called Medici porcelain continued for a few decades after Francesco's death in 1587, after which, curiously, porcelain was not produced again in Europe for more than one hundred years.

In addition to Chinese blue-and-white porcelain, pottery composed of a white, slip-covered fritware made in Iznik and Kütahya, Turkey, exerted a strong influence on Medici porcelain. These ceramics produced under Ottoman rule feature characteristic foliate and floral ornament in blue and white as well as in polychrome colors, including bole, an iron-oxide-colored clay that, in liquid form, rendered tomato red decoration (pls. 38, 40–41). Other motifs include carnations, palmettes, roses, and feathery leaves that also appear on certain Medici porcelain examples. Commonly called Iznik pottery, this production began arriving in Italy by the sixteenth century and was imitated there soon afterward,[92] although its vitreous body and brilliant painting on a pure white ground must have made it practically indistinguishable from Chinese porcelain at the time for all but connoisseurs.[93]

The question of whether Italian ceramic painters copied actual Chinese blue-and-white porcelain or Islamic types imitating that porcelain has yet to be unraveled, as has the question of how this material arrived in Italy. An interesting case is the depiction of three blue-and-white bowls by Giovanni Bellini (ca. 1430–1516) in his *Feast of the Gods*, an enormous painting executed for Alfonso d'Este I and completed by Titian (ca. 1485–1576) after Giovanni's death (fig. 9). The bowls in the painting seem to be "portraits" of actual pieces: two are probably Chinese and one may be Iznik. A hypothesis speculates that Giovanni's brother Gentile may have acquired the pieces during his stay in Istanbul, where the Chinese bowls could have been sent as diplomatic gifts.[94] Their inclusion in the painting must have pleased the duke, who, as we have seen, was keenly interested in porcelain.

Throughout this period Italians continued importing and ordering ceramics from abroad, especially from Syria, Turkey, and Spain.[95] That Italian potters occasionally copied "foreign" types, sometimes very closely, is further evidence that these imported products appealed to local clients. In Tuscany, where the influence of Spanish ceramics was strong, potters working in centers such as Montelupo imitated the dense vine and bryony leaf patterns characteristic of Valencian pottery.[96] In Liguria ceramic painters adopted the so-called scrolling calligraphy patterns in imitation of a type of Ottoman blue-and-white decoration of spirals and comma-shaped leaves based on manuscript illumination.[97] Another area whose local port connected Italy with the Islamic Middle East was the Veneto, where, probably in and around Padua, more traditional Iznik polychrome patterns, including tulips, feathery *saz* leaves, and carnations, were copied.[98] At a time when Italian ceramic painters had developed their own masterful visual idiom, such imitations of foreign products, although produced in limited numbers, must have resulted from an attraction to the more exotic product, whose value was well established.

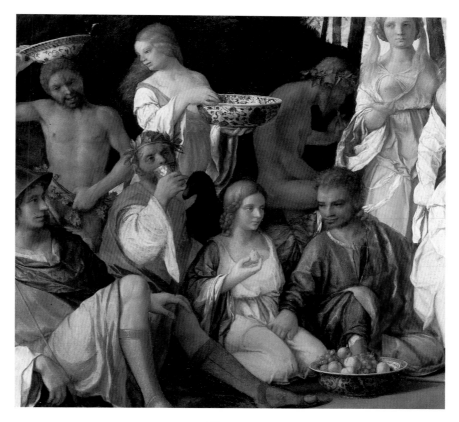

Figure 9
Giovanni Bellini (ca. 1430–1516) and Tiziano Vecellio, called Titian (ca. 1485–1576).
The Feast of the Gods, 1514–29 (detail). Oil on canvas, 170.2 × 188 cm (67 × 74 in.).
Washington, D.C., National Gallery of Art, Widener Collection, 1942.9.1.

According to one scholar, the remarkable development of the decorative arts—notably, glass and maiolica—that took place in Italy created "an almost total upset of the commercial balance of those products" and "a collapse of the trade from the Near East to Italy."[99] What accounts for the success of these industries? Geography played a role. Italy is a peninsula jutting into the center of the Mediterranean, at the heart of lively sea traffic. Just as Sicily's proximity to North Africa and eastern Spain's orientation toward the Tyrrhenian Sea determined routes of ceramic transmission, the position of Venice—an active port since the Middle Ages, linking the East and West—fostered the city's glass industry. In addition to exposing the local population to varied art forms and technologies, Venice's trade connections helped solve the problem that Venice, as an archipelago, had to import all raw materials for glass production.

Population also played a role. During the second half of the fourteenth century the plague ravaged Italy, reducing its population by roughly one-third. Some scholars argue that one result of this terrible mortality was that more resources—accumulated wealth as well as foodstuffs—were available to fewer people, making the populace generally richer and better fed.[100]

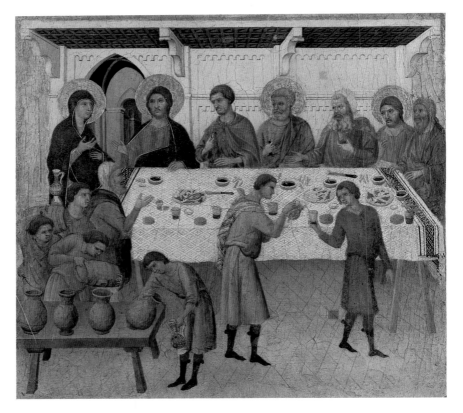

Figure 10
Duccio di Buoninsegna (ca. 1255–ca. 1319).
The Wedding Feast at Cana, Italy, Siena, 1308–11. Tempera on wood,
43.5 × 46.5 cm (17 ⅛ × 18 ¼ in.).
Siena, Museo dell'Opera del Duomo. Photo: Scala / Art Resource, New York.

This sparsely furnished table includes a few bowls and glass beakers,
as well as three serving dishes and two knives.
Bread and discarded bones are also placed on the modest tablecloth
of brocaded linen and cotton.

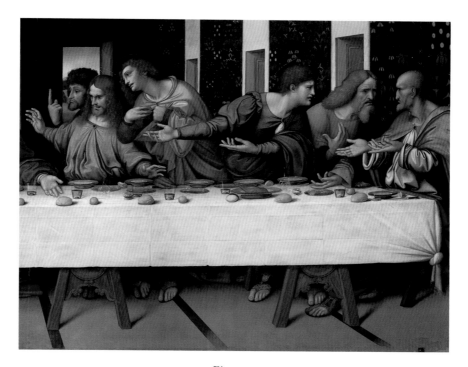

Figure 11
Giovanni Pietro Rizzoli, called Giampietrino (active 1508–49).
The Last Supper (after Leonardo da Vinci [1452–1519]), ca. 1515 (detail). Oil on canvas,
302 × 785 cm (118 × 309 in.). London, Royal Academy of Arts, London;
on permanent display in the chapel of Magdalen College, Oxford.

On this simple but elegant table, each diner has a separate tablesetting
on the pressed linen tablecloth.

Tableware

WHATEVER THE ROLE OF THE BLACK DEATH, the general diet became more varied and, together with the current interest in luxury and lavish display, this diet involved more elaborate meals, requiring more specialized table settings, including dishes and drinking vessels (figs. 10–12). A new type of gastronomic literature began to flourish, including the mid-fifteenth-century *Libro de arte coquinaria* (The art of cooking), by Martino da Como, who worked for such illustrious men in Milan as Duke Francesco Sforza (1401–1466) and military captain Gian Giacomo Trivulzio (1441–1518), and, slightly later, *De honeste voluptate et valetudine* (On honest pleasure and good health), a reworking of da Como's recipe book by his friend Bartolomeo Sacchi (1421–1481), known as Platina, who served as cook to Pius V (pope, 1566–72). These works refer to such aesthetically oriented preparations as "heavenly blue sauce

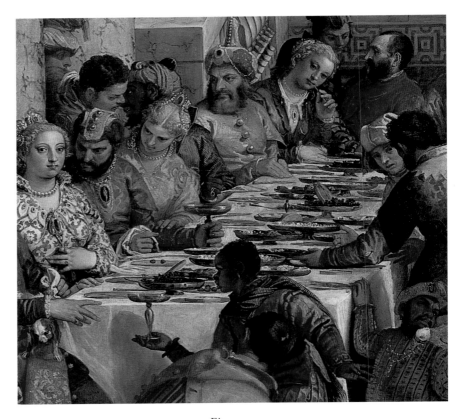

Figure 12
Paolo Caliari, called Veronese (1528–1588). *The Wedding Feast at Cana*, 1562–63 (detail).
Oil on canvas, 666 × 990 cm (262 × 389 in.). Paris, Musée du Louvre, 142.
Photo: Réunion des Musées Nationaux.

This sumptuous meal is presented on a table crowded with elegant serving
and dining vessels.

for summer," "vine-tendril relish," and "trout eggs prepared so they
seem to be peas." Pinnacles of such a culinary style surely must have
been the meals served in the Este court in the 1520s, 1530s, and 1540s that
are described by Cristoforo Messisburgo in his *Banchetti, composizioni
di vivande, e apparecchio generale* (1549). The variety and complexity of these
meals are stupefying. One meal serving fifty-four guests consisted of
over twelve courses of 140 separate foods, totaling more than twenty-
five hundred plates. At other meals elaborate delicacies—"roast peacock
emblazoned with the cardinal's insignia," "truffles boiled in white wine,
sliced, fried, and served with a sauce of orange juice and pepper," and
"'Neapolitan' pasta cooked in milk and served with butter, cinnamon,
and cheese"—typify the many dozens of other dishes served at a single
meal. Between courses guests washed their hands in "fragrant water."[101]

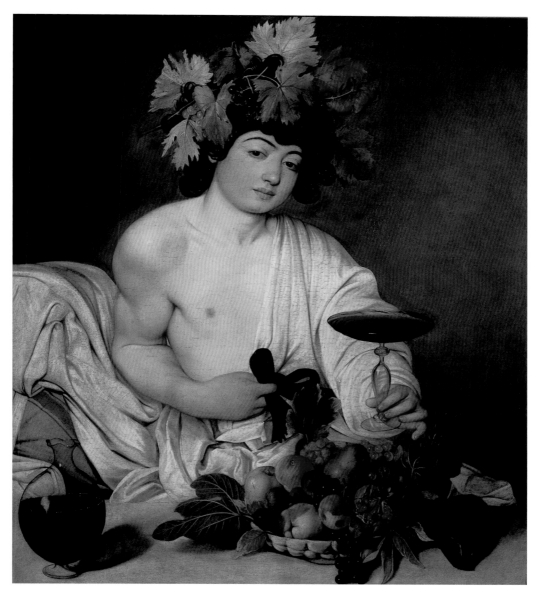

Figure 13
Michelangelo Merisi, called Caravaggio (1573–1610). *Young Bacchus*, ca. 1596.
Oil on canvas, 95 × 85 cm (37⅜ × 33½ in.).
Florence, Galleria degli Uffizi, 5312. Photo: Scala/Art Resource, New York.

The red wine is beautifully presented in a Venetian glass bottle and *tazza*,
and the leafy fruit sits in a maiolica whiteware *crespina*.

Pictorial representations inform us that glassware was common on dining tables. Since no comparable and reliable fifteenth- or sixteenth-century representations exist for fancy maiolica vessels, some controversy remains regarding their function. It is possible that particularly elaborate examples were used simply for display on a sideboard or shelf. Nevertheless, evidence suggests that fine maiolica was, indeed, used for dining, although probably not for everyday meals. The various shapes of maiolica imply a range of fare presented to diners, with separate vessels used for roast peacock, boiled truffles, milk pasta, and so on. Many pictorial depictions show so-called *crespine* (molded dishes) holding fruit; their particular undulating shape may have served to circulate air to retard spoilage (fig. 13).

As documented by Piccolpasso in 1557, maiolica bowls and plates were made as parturition dishes for women in confinement after childbirth. Documentary evidence exists in the form of a letter written in 1524, in which the duchess of Urbino tells her mother, Isabella d'Este (1474–1539), that the exceptional maiolica service she had given Isabella is probably most suitable for her country home at Porto.[102] Two other plates — one from the service made in 1535 for Cardinal Antoine Duprat (1463–1535) and the other dated 1577 and probably made in Padua — provide rare firsthand proof that fine maiolica was used during meals. The Duprat plate represents David and Goliath in a landscape setting in which the painted river on the front disappears "underground." The hidden cavity under the plate must have been used to drain off liquid from the food it held. The 1577 plate — painted with scrolling foliage, birds, and an overall ground of dots — includes a prominent banderole with the words "per meter uno pesco di vitello alleso" (for placing a piece of boiled veal).[103] Certainly the dining function of maiolica is later well established. In his seventeenth-century essay on how to run a house, Antonio Adami writes that important men "would like their food to be prepared and served on white maiolica because it is cleaner than copper and doesn't give food a bad taste . . . and princes drink from clear glass even if they have cups, beakers, and vessels of gilt silver . . . because [drinking from] a vessel of clear glass is more appetizing and pleasing."[104]

The interest in cleanliness went hand in hand with a new self-consciousness at the Renaissance table that emphasized good manners and refinement. Indeed, Italians traveling abroad noted the barbarity of the table manners they encountered just as English and French visitors to Italy mentioned the luxury and refinement in dining at Italian tables.[105] Codifying and promoting these standards was a proliferation of literature concerned not only with the preparation of food but also with its consumption.[106] Rather than the medieval practice of sharing bread or wood trenchers, vessels, and even knives (the only utensil then used), diners now were granted individual place settings and used flatware instead

of the twentieth century at Sirkeci on the south shore of the Golden Horn (Atasoy and Raby 1989, pls. 307, 309, 318, 328–30, 333, 336, 347; Vitali 1990, 245–46, figs. 26–27; Curatola 1993, nos. 299–300, 481–83).

98. The Italian versions are often called *candiane* because of an example inscribed with this name at the Musée de la céramique, Sèvres (inv. 4617); the meaning of this inscription is unclear (Fontana 1989, 128–30, figs. 18–26; Curatola 1993, no. 301, 483–84).

99. Spallanzani 1989, 85.

100. Bean 1982, 23–33.

101. Messisburgo [1549] 1960, 31–99.

102. Casali 1987, 211n. 29.

103. J. V. G. Mallet in Mallet and Dreier 1998, 35; Coutts 2001, 33, fig. 40.

104. Antonio Adami, *Il noviziato del maestro di casa* (Rome, 1657), 166–67.

105. Goldthwaite 1989, 26–27.

106. Eustachio Celebrino, *Opera nuova che insegna apparecchiare una mensa a un convito* (Cesena, ca. 1530); Giovanni della Casa, *Galateo, overo de' costumi* (Venice, 1564); Bartolomeo Scappi, *Opera o epulario* (Venice, 1570); Vincenzo Cervio, *Il Trinciante* (Venice, 1581).

107. Montanari 1994, 92.

108. Goldthwaite 1989, 6, 21–22.

109. Caiger-Smith 1973, 101.

110. "Se viverai sansa freno, ogni bene ti verrà meno" (*Libro di buoni costumi* cod. 1383, Biblioteca riccardiana, Florence, in Branca 1986, 86, no. 364).

111. "Molto è bella cosa e grande sapere guadagnare il danaio, ma più bella cosa e maggiore è saperlo spendere con misura e dove si conviene" (*Libro di buoni costumi* in Branca 1986, 81–82, no. 81).

112. *Preface to Book 1 of the Aristotelian Treatise on Economics, or Family Estate Management. Addressed to Cosimo de' Medici* in Griffiths, Hankins, and Thompson 1987, 305.

113. "Magnum se et quidem in magnis sumptibus praebere debere" (Pontano 1999, 172–74).

114. "Il ghuadangnare e lo spendere sono del numero de' grandi piaceri che gl'uomini piglino in questo mondo, e ffassi difichultà quale sia il maggiore di questi due. . . . Io non avendo mai fatto altro da cinquanta anni in qua se non ghuadangnare e spendere . . . achordomi sia maggiore dolcezza lo spendere che il ghuadangare. . . . Credo che m'abbi facto più honore l'averli bene spesi ch'avergli guadagnati e più chontentamento nel mio animo" (Perosa 1960, 118–21).

115. Goldthwaite 1989, 20.

116. Udovitch 1993, 767–90.

117. A fonduk is an urban structure or series of structures as opposed to the rural caravansaray.

118. And, in the case of the caravansaray, as a stable for animals.

119. See, for example, Constable 2003.

120. Goldthwaite 1989, 18–19, 30–32; see also Jardine 1996, esp. chaps. 6, 8.

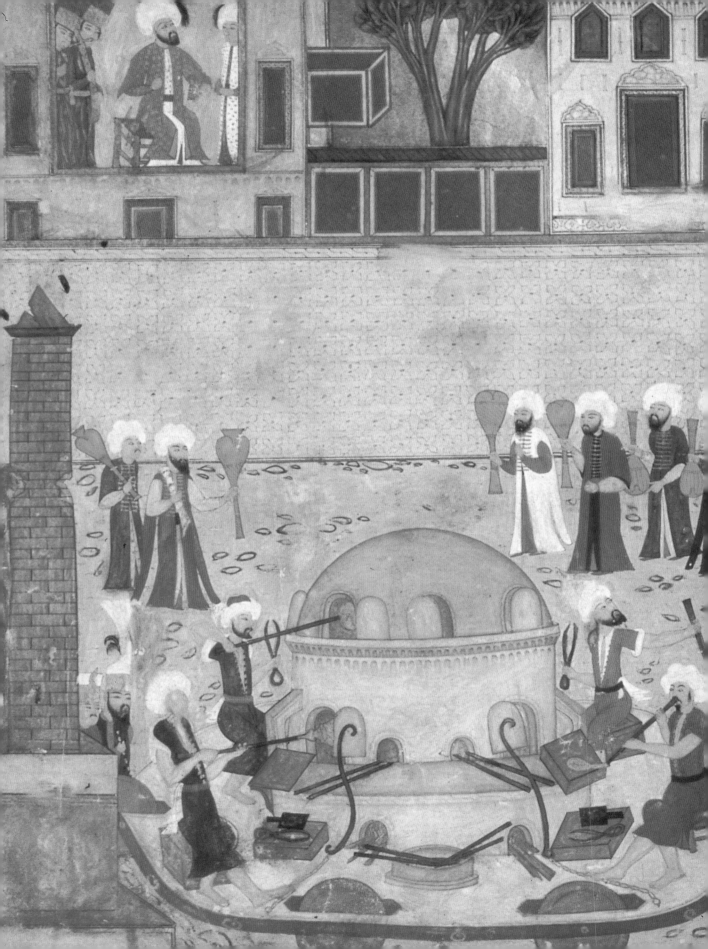

Color, Precious Metal, and Fire: Islamic Ceramics and Glass

LINDA KOMAROFF

> I myself... came to the full Nile in a barbarian boat... having
> gone up the river for five days we came to the great palace
> of the Sultan [in Cairo]. But who could describe how huge the
> city is, full of a multitude of houses, populous and abounding
> in all manner of barbaric wealth.
>
> —*Cyriacus of Ancona to Eugenius IV, 1441*[1]

FROM THE RENAISSANCE ONWARD the Islamic arts of the object—
surely one manifestation of the "barbaric wealth" referred to above—
have fascinated and intrigued Westerners, provoking, among other things,
a desire to possess them through acquisition, imitation, or reinterpreta-
tion. What were these obscure objects of desire? They are simple enough
to define, especially if set between the polarities of Islamic architecture
and the arts of the book. They are the "everything else" that might describe
the material culture of the ruling elite and privileged classes in the Islamic
world in a period stretching over well more than a millennium and in an
area extending from southern Spain to northern India. Brilliantly glazed
pottery and tiles, enameled and gilded glass, inlaid metalwork, carved
wood and stone, and sumptuous woven textiles and carpets all absorbed
the creative energies of artists to become highly developed art forms.
Such objects, meticulously fabricated and carefully embellished, often with
rare and costly materials, were for the most part portable, so portable that
the vast majority have long since been removed from an original context.

Opposite: *Parade of the Guild of Glassblowers* from *Surname-i Hümayun*, ca. 1582 (detail). Opaque
color on paper, 30 × 20.8 cm (11¾ × 8⅛ in.). Istanbul, Topkapi Palace Museum Library, inv.
H. 1344, fols. 32b–33a.

These objects may be viewed in many different ways, in part because they have led multifaceted lives. For example, an enameled and gilded glass lamp (pl. 6) was made in the mid-fourteenth century for a building in Cairo. It was later transported to Europe, probably in the nineteenth century, when such objects were avidly collected and imitated by European glassmakers. In 1936 the lamp became the property of the American collector William Randolph Hearst (1863–1951), who gave it to the Los Angeles County Museum of Art in 1950.[2] In art-historical literature the life story, or "biography," of an object or class of objects is essentially concerned with how they were viewed or received, very often beyond and apart from the context of their original creation. Such "biographical" information is particularly germane when considering Islamic arts of the object—given their portability and tremendous attraction for Westerners.

Examples of enameled glass from the Mamluk period (1250–1517) in Syria and Egypt found their way to Europe as early as the fourteenth century.[3] These glasswares, produced primarily between 1300 and 1400, owe their strong appeal to their technical virtuosity. In such works polychrome enamels and gilding were applied cold and then carefully fixed in a low-temperature kiln. In the mid-nineteenth century a popular taste for this glass exploded in Paris, the center for the market in Islamic art. At that time Cairo was the single greatest repository of Mamluk art—including enameled glass, such as the lamps that were specially commissioned to illuminate the numerous religious monuments constructed by the Mamluks. Cairo became the most important source for the acquisition of enameled glass. Ironically, the increasingly rapid disappearance of works of art from Cairo's mosques and charitable institutions, due largely to the rapaciousness of Western collectors, contributed to the creation in 1881 of the European-dominated Commission for the Preservation of the Monuments of Arab Art.[4] The commission began to transfer works of art from religious monuments to a central repository in Cairo, which formed the basis of the Arab Museum (later renamed the Museum of Islamic Art). European taste for enameled glass also inspired glassmakers in France, Italy, and Austria to imitate Mamluk glass, which would have been in short supply once the commission began removing lamps from mosques and other religious institutions.[5]

At around the same time that Europeans were clamoring for Mamluk enameled glass, they were also developing a keen appetite for luster-painted ceramic wares, primarily in the form of star-shaped tiles from Iran (pl. 18). Such luster tiles, which served as architectural revetment on secular and especially religious edifices of the thirteenth and fourteenth centuries, were painted with a metallic compound and refired. They were admired by Europeans for their wondrous reflective surfaces and perhaps

because they fed an imagined idea of the Orient and served as "a revelation of a lost art redolent of the romance of the East."[6] To satisfy this demand several individuals, who seem to have had some relationship to the government of the reigning Qajar dynasty (1779–1924), helped procure large quantities of tiles, thereby stripping entire buildings of their decoration. A prominent figure in these endeavors was the director of the Persian Telegraph Department in Tehran, Robert Murdoch Smith (1835–1900), who in 1873 became an agent for the South Kensington (later Victoria and Albert) Museum in London.[7] His acquisitions initially were accompanied by reports detailing from which building the tiles had been taken, but in 1876 the Qajar government, urged on by religious authorities, issued a pronouncement against the pillaging of religious monuments. Although this injunction does not appear to have affected Smith's continued acquisition of tiles, it does seem to have led to his deliberate falsification of facts regarding their provenance.[8]

European collections and patterns of collecting have shaped and altered popular as well as scholarly perceptions of Islamic art. But in terms of the study of the objects themselves, their reception in Europe is largely just an interesting postscript. Their real lives, as it were, are embedded in another cultural tradition with its own special visual language and distinct meanings.

Islamic ceramics and glass, the subject of this essay, share several traits. Both are made from humble and highly plastic materials that undergo a remarkable transformation through firing. Based on their common chemistry, glazed ceramics and glass have a familial relationship, as the glaze itself is a special form of glass. In the early Islamic period (seventh–tenth century) the two media each drew on pre-Islamic artistic traditions, especially from the late Roman or Byzantine territories in the eastern Mediterranean. Ceramics and glass (along with metalwork, both base and precious) often exhibit the same shapes, and at times the two make use of the same colorant techniques—luster and enamel. Both served as a substitute for more costly metalwork, especially precious metal, the use of which as tableware was proscribed for Muslims in Hadith literature.[9]

Both can range in quality from modest utilitarian objects to the highest level of luxury ware, although comparatively few bear direct evidence of royal patronage. Further, both mediums frequently demonstrate the virtuosity of the Islamic artist and the evident demand within medieval Islamic society for functional objects of exquisite beauty.

The period spanned by the ceramics and glass here under discussion—the ninth through the sixteenth century—comprises an enormous topic and covers a vast geographical area, even when restricted to two mediums. Given the common characteristics of glass and ceramics, it seems most profitable to discuss the two together in chronological fashion.

While the dynasties whose rise and fall characterize Islamic history often lend their names to the art of a given period, this essay will rely on a broader four-part chronology that subsumes dynastic distinctions:

EARLY ISLAMIC (seventh through tenth century) represents the origins of Islam, the birth of a religious, political, and cultural commonwealth, and the development of a new manner of art.

EARLY MEDIEVAL (eleventh through mid-thirteenth century) describes the emergence of autonomous regional leadership, which promoted distinctive forms of cultural expression.

LATE MEDIEVAL (mid-thirteenth through fifteenth century) delineates the continuance of regional dynasties in the aftermath of the cataclysmic Mongol invasions.

LATE ISLAMIC (sixteenth century onward) characterizes an age of great empires, in which dynamic dynastic patronage gave greater impetus to the creation and molding of artistic styles.

Early Islamic Period

THE ISLAMIC PERIOD has a fixed starting point — A.D. 622, the year of the hegira (*hijra*), marking the emigration of the Prophet and his followers from Mecca to Medina. But it is hard to date precisely the beginning of Islamic art. It seems to have evolved gradually during the first centuries of Islamic rule and is distinguished by the transformation and imaginative adaptation of pre-Islamic artistic ideas. Glass from this period often employs Roman forms and techniques but refashioned to satisfy a new taste or to serve new needs. Blown glass (free blown or blown in a mold, a technique developed in the first century B.C., in the eastern part of the Roman Empire, probably in Syria), continued to be produced without disruption into the early Islamic period. There is little obvious technical difference between a late Roman free-blown vessel with applied ornament (pl. 1) and one datable to the early Islamic period (pl. 3). Formalistically the two vessels are unrelated. The early Islamic example is a charming perfume container in the guise of a kneeling quadruped, probably a camel, which exemplifies an important aspect of Islamic art — the transformation of a natural form into something more abstract. Here, for the animal to metamorphose into a functional vessel, the form has been reduced to its most elemental yet recognizable parts. The elegant, curved neck of the camel is elongated to serve as the vessel's spout, the hump is reconfigured as the handle, and the tiny, almost vestigial feet represent the legs folded beneath the beast.

Perhaps one of the most important technical achievements carried forward into the early Islamic period (in this instance from Byzantine Egypt) was the painting of glass with metallic pigments. A paste made of silver and copper compounds along with a reducing agent was applied to the surface of the glass, which was then fired at a low temperature to produce what today appears as a muted palette of yellow, brown, orange, and/or red decoration. Glass decorated in this technique, known as luster painting, was made in Egypt and Syria in the eighth century and by the ninth century the technique was known in Iraq.[10]

A deep bowl with golden and orange-brown luster painting, likely produced in Egypt or Syria, bears ornamentation that ties it to the early Islamic period (pl. 15). An Arabic inscription beneath the rim has so far defied the skills of the epigrapher, but the style of writing, in a script generically known as Kufic, suggests a ninth-to-tenth-century date.[11] The vegetal devices within compartments encircling the vessel—trunks or branches punctuated by dots or commalike forms—also relate to the arts of the book, to Koranic illumination, where similar types of designs are used in horizontal fashion to separate chapters.[12] Similarly, the overall decorative scheme, reminiscent of an arcade with alternating wide and narrow archlike compartments (ultimately drawn from the vocabulary of classical art, although it is also found in early Koranic illumination), can be compared to that of objects in other media from this period.[13]

Comparatively few complete luster-painted glass objects have survived.[14] Instead, luster painting is best known through Islamic ceramics, beginning in ninth-century Iraq and extending to Egypt, Syria, North Africa, Spain, and Iran. Luster-painted ceramics represent one of the most original and spectacular contributions of the Islamic potter. This is an especially long-lived technique, and the resulting product must have always been considered a form of luxury ware, given its costly materials and manufacturing process.[15] The secret of luster painting was probably closely guarded, even kept within a single family, such as the Abu'l-Tahir family, active for more than four generations in the thirteenth and fourteenth centuries in Kashan, Iran, the preeminent center for Persian lusterware. At the beginning of the fourteenth century a member of this family, Abu'l-Qasim, who pursued a career as a historian rather than a potter, wrote a treatise on the making of pottery and tiles, including a section on luster.[16] His instructions called for two firings. For the first firing, an opaque, generally white glaze was applied, while for the second, the design was put on with a paste of silver and copper compounds ground with sulfur and dissolved in grape juice or vinegar. The second, all-important firing occurred in a special kiln that restricted the flow of oxygen to produce a reducing atmosphere that forced the metals to give up their oxygen, thereby creating a thin lustrous film that fused with the glazed surface. After firing, the cooled ceramic was polished with damp earth to expose the

luster. When the firing process was successful, the result was an object that "reflects like red gold and shines like the light of the sun."[17]

It is generally assumed that this technique was first introduced to potters in Iraq in the ninth century by Egyptian artists familiar with the secret of luster-painted glass, who had perhaps immigrated to the wealthy courts of the caliphate in Baghdad and in Samarra (836–92), under the Abbasid dynasty (750–1250).[18] Much of the earliest luster-painted pottery differs slightly from the wares realized by Abu'l-Qasim's recipe, in which the emphasis was on obtaining a golden hue. Ninth-century luster—as demonstrated by objects excavated at the great palace complex at Samarra or the tiles said to have been sent from Baghdad to the Great Mosque of Kairouan, Tunisia (ca. 862–63)—are generally polychromatic. The range in colors, including red, green, brown, yellow, and gold, suggests a period of experimentation as potters sought to control this complicated technique by varying the specific content of the metal compounds and the kiln conditions.[19]

A deep bowl painted in yellow and brown luster over a white glaze and decorated with abstract and vegetal designs is an excellent example of the more colorful phase of this technique (pl. 16). The prominent split-leaf motif marking the four quadrants of the bowl is perhaps an abstracted, vegetal version of a pair of wings. Often employed as a design element in early Islamic art, the wings ultimately derived from the royal crown of the Sasanian dynasty (224–651), the last pre-Islamic rulers of Iran.[20] Such a royally inspired motif does not necessarily connote a courtly patron; the costly technique does, however, suggest that the bowl was made for someone of financial means.

Contemporary texts—for example, the often-repeated account of the much-admired Chinese imperial porcelain sent by the governor of Khorasan, in eastern Iran, to Harun al-Rashid (r. 786–809)—testify to the appreciation for Chinese ceramics by the Abbasid court, which was renowned for its wealth, opulence, and extravagance.[21] Chinese ceramics have also been excavated at various sites throughout the Abbasid Empire, including Samarra, Siraf (a port city on the Persian Gulf), and Fustat (Old Cairo), signifying a taste for these costly imported wares that must have extended beyond the court.[22] To satisfy that taste Islamic potters in the ninth century began to imitate the whiteness of high-fired porcelain by covering low-fired earthenware with an opaque white glaze of tin oxide.

While the shapes of these ninth-century tin-glazed wares often follow Chinese prototypes, the decoration demonstrates far greater originality. In contrast to the pure white surface of the originals, the raw glazed surface was now painted with cobalt blue, copper green, or manganese purple designs. Fixed in a single firing, the paint or stain on the white glaze had a slightly diffuse effect that has been prosaically compared

to "ink on snow."[23] Both vegetal and geometric motifs are common, as in, for example, a bowl decorated in cobalt blue and combining these two types of motifs (pl. 14). This predilection for blue on white predates the production of Chinese blue-and-white porcelain, which was not made for export to the Islamic world until the fourteenth century.[24] Imported blue-and-white porcelain was collected and imitated in the late medieval and late Islamic periods, but Chinese porcelain had a more immediate impact on the pottery of the early medieval period.

Early Medieval Period

ISLAMIC POTTERS INVENTED AN ARTIFICIAL ceramic body to replicate the white color, lightness, and translucency of Chinese porcelain, since a key ingredient for producing porcelain—kaolin—was unavailable to them.[25] Known as fritware or stone-paste ware, this type of pottery seems to have appeared almost simultaneously in Egypt, Syria, Iran, and elsewhere by the twelfth century. It soon replaced the darker, heavier earthenware as the preferred material of most Islamic potters. The manufacture of fritware is described in the treatise by Abu'l-Qasim. There the recipe calls for ten parts silica or ground quartz, one part glass frit, or partially fused glass, and one part fine white clay, to be mixed into a paste that is kneaded like dough.[26] Although they developed frit-ware for its whiteness, Islamic potters quickly began to add color effects, such as overglaze luster-painted decoration.

The art of luster-painted ceramics was likely introduced to Iran in the late twelfth century, probably from Egypt, where it had been in use since at least the early eleventh century (fig. 1).[27] Kashan appears to be the primary documented center of production in Iran, although luster-wares ascribed to this site demonstrate various painting styles. Among the most impressive are those of the "monumental style," so called because of the typically large-scale designs and dynamic manner of presentation.[28] Characteristically, a boldly painted single figure occupies most of the decorated space, usually the center of a bowl, while thick scrolling pal-mettes fill the interstices. The main design is reserved on the generally white, glazed surface, while the details and background are filled in with luster. Horsemen, hunters, and musicians as well as a range of animals, including mythical beasts, such as the harpy (pl. 17), make up the some-what limited decorative repertoire.[29]

A hallmark of the Kashan style is the use of plump birds, reserved in white, both standing and in flight. These most often occur as a sub-sidiary design, but at times such birds provide the main decoration (pl. 29), while tiny spirals and commalike designs are typically scratched through the luster surface. Inscriptions, frequently rendered in a cursive

Figure 1
Bowl. Egypt, twelfth century. Earthenware, overglaze luster painted
on blue ground, H: 6.5 cm (2 9/16 in.), DIAM: 17.3 cm (6 13/16 in.).
Los Angeles County Museum of Art, The Madina Collection of Islamic Art,
gift of Camilla Chandler Frost; M.2002.1.35.

script, generally present Persian poetry. Dates and signatures are less
common, and rarer still are inscriptions giving the name of a courtly
patron.[30] When the golden iridescence of the luster is well preserved, as
in, for example, the bowl with birds (pl. 29), it is easy to appreciate
the tremendous appeal of these wares and their role as luxury objects,
perhaps mainly intended for an affluent, sophisticated urban clientele.[31]

Although the production of luster in Syria begins about a century
earlier than in Iran, its introduction again may be the result of émigré
Egyptian potters. At present there is evidence to suggest two main centers
of production, Tell Minis, in central Syria, the site to which the earliest
lusterwares are attributed, and the city of Raqqa on the Euphrates.[32]
Figural ornament seems more typical of the former, earlier, site, while
lusterwares from Raqqa, dating to the late twelfth and early thirteenth

centuries, are often decorated with abstract and vegetal designs. In contrast to Iranian lusterwares, the luster on those objects ascribed to Raqqa is generally a deep chocolate brown over a grayish glazed ground, which can be combined with an underglaze-painted blue. This category is exemplified by a storage jar whose body is divided into vertical bands filled with scrolling vegetal designs (pl. 32). This type of jar, with concave sides, which allowed for easier handling when closely arranged with other such vessels, became known in fifteenth-century Italy as an *albarello* (and is recognized today as the classic apothecary jar). The shape was evidently introduced to Europe through imported Islamic examples, which were produced over a wide area, including Syria, Egypt, Iran, and Spain. Such Islamic albarelli probably initially served a purely utilitarian function as shipping containers for the costly spices exported to Italy and elsewhere.

While the great period for enameled glass is the late thirteenth and fourteenth centuries under the Mamluk dynasty, the technique began earlier in the thirteenth century. An elegant long-necked bottle inscribed with the name and titles of a member of the Ayyubid dynasty who ruled in Aleppo (1237–60) and Damascus (1250–60) is the earliest datable example.[33] Other enameled glass objects may also be ascribed to this earlier period—including a group of beakers with wide, flaring mouths and a limited decorative scheme.[34] The eulogistic inscriptions generally begin with the phrase "Glory to our master," a formula well known in the Ayyubid and Mamluk periods, but the titles mentioned on the beakers do not identify a particular individual. Vessels of this type, with enameled decoration restricted to generic inscriptions (pl. 7), nonetheless help flesh out the early history of this spectacular glass technique.[35]

Late Medieval Period

THE BEST-KNOWN AND MOST IMPRESSIVE examples of enameled and gilded glass belong to the period of Mamluk rule in Egypt and Syria, particularly of the late thirteenth to mid-fourteenth centuries. The peculiar historical circumstances of this dynasty relate to the production of much of this glass. Members of this dynasty rose from the ranks of Turkish-speaking, imported military slaves, known as "mamluks," who seized power from their former masters in 1250. One of the most remarkable aspects of the Mamluks was their creation of a new, self-perpetuating ruling class, which excluded members of the indigenous population and often prevented even their own heirs from succeeding to their position and property. In part as a means of allowing their offspring to profit by their wealth, the Mamluks built and lavishly endowed innumerable religious foundations, which were controlled by their descendants.[36] Their capital, Cairo, especially benefited

from their building activities, for which all manner of furnishings were commissioned, including glass lamps.

Given the large number and often vast scale of the Mamluk foundations—mosques, *madrasas* (theological colleges), mausoleums, and *khanaqahs* (Sufi hospices)—the beautiful oil lamps that served to light these structures must have been produced in enormous quantity, probably both in Egypt and Syria.[37] Free blown with applied handles for suspension, the lamps have a very characteristic form with a tall, flaring neck and a compressed, globular body, supported by either a high, conical foot or a thick foot ring. Their brilliant enamel colors—essentially colored vitreous pastes painted on the glass and fused to the surface by firing—generally include red, blue, yellow, green, and white. Gold, used to outline or fill in designs, was applied as a liquid suspension and was fixed by firing at the same time as the enamels.[38] Bold, rhythmic Arabic inscriptions are often the dominant decorative element. The lamps are typically inscribed around the neck with an especially appropriate quotation from the Koran (XXIV:35) in which the light of God is likened to the light from an oil lamp. Generally only the first few words ("God is the light of the heavens and of the earth") of the verse are transcribed, but they are a sufficient reminder of the full text (which continues: "His light is as if there were a lustrous niche wherein is a lamp. The lamp is in a glass. The glass is as it were a shining star."), of which the lamp itself is a tangible re-creation.

Often inscriptions on the lower part of the lamp supply the name and titles of the individual who commissioned it, while a heraldic device, known as a blazon, which specifically pertains to its patron, is often repeated on the upper and lower sections of the lamp (pl. 6): "By order of the most noble authority, the Exalted, the Lordly, the Masterful, holder of the sword, Shaykhu al-Nasiri." Shaykhu was a former mamluk of al-Nasir Muhammad (r. 1294–1340, with interruptions). The accompanying blazon, a circular medallion bearing a red cup set between a red and a black bar, refers to Shaykhu's earlier and baser status as a royal cupbearer. This powerful and wealthy emir is known to have built a mosque and a *khanaqah* in Cairo in the mid-fourteenth century, and the lamp was most likely made for one of these structures.[39]

Enameled and gilded glass was also made for personal, secular use. Primarily vessels, many of these objects can be classified as tableware, for example, beakers, bottles, and bowls, of which the latter are often set on a tall foot. A footed bowl, or *tazza* (pl. 4), comparable to a European chalice, likely served as a drinking vessel.[40] Another popular vessel—a tall, long-necked bottle with a compressed, spherical body—was probably intended as a decanter for wine.[41] During the Mamluk period many shapes found in enameled and gilded glass were produced in other media, especially metalwork and ceramics.

One shape produced in several different media is the so-called pilgrim's flask, or canteen. It can be generally described as a globular vessel, flattened on the sides, with a pair of looped handles at the shoulder and sometimes at the neck. Known in enameled and gilded glass, inlaid metalwork, and glazed ceramic, while a related shape is also found in late-fifteenth- and early-sixteenth-century Venetian glass (pl. 12), the pilgrim's flask was most frequently produced as a humble unglazed ceramic vessel.[42] These utilitarian water vessels, probably left unglazed to allow evaporation to keep their contents cooler, are nonetheless often richly decorated and may even be inscribed with the name of their maker. For example, an inscribed band surrounding a central medallion with an elaborately coiled knot motif dominates a canteen with molded decoration identical on both sides (pl. 25). The inscription offers good wishes and provides the name of its maker, a certain al-Mufid.[43] Such unglazed, molded canteens, especially associated with Syrian pottery workshops, must have been made for both soldiers and their officers, as some bear the blazons or heraldic devices of high-ranking emirs.[44]

The Mongol invasions of western and eastern Asia in the early and mid-thirteenth century had an incalculable impact on contemporary societies. Although the Mamluks famously halted the Mongol juggernaut in 1260 at Ain Jalut (Spring of Goliath), near Nazareth, the new chinoiserie-inflected artistic language that had developed in Iran as a consequence of Mongol rule easily penetrated Mamluk art and culture.[45] Direct contact through imported Chinese objects, such as textiles and blue-and-white porcelains in the fourteenth century, also helped disseminate a fresh visual vocabulary to Mamluk artists.[46] In addition to the outright imitations produced in late-fourteenth- and fifteenth-century Syria (fig. 2),[47] fourteenth-century Chinese blue-and-white porcelains also stimulated Mamluk potters to produce tile revetment in cobalt blue (and sometimes black, occasionally with turquoise or green borders) on a white ground. The decoration of these hexagonal and rectangular tiles typically combines Chinese-inspired vegetal motifs with an Islamic preference for symmetry and designs, such as the image of a spherical-bodied ewer resting on a stand (pl. 9).[48] In the late Islamic period Chinese blue-and-white porcelain would have an even more significant impact on the development of Ottoman ceramics.

In the late medieval period glazed tile revetment was far less common in Mamluk buildings than in Iran under the Ilkhanid dynasty (1256–1353), the descendants of Genghis Khan (ca. 1162–1227). Decorated in the luster technique, alternating star- and cross-shaped tiles served as a sparkling, ornamental skin covering the mundane brick interior walls of secular and especially religious monuments in Iran, beginning around 1200. The kilns of Kashan, the main center for tile production, were slowed down but not stopped by the Mongol invasions of the thirteenth

Figure 2
Dish. Syria, fifteenth century. Underglaze-painted fritware,
H: 5.7 cm (2¼ in.), DIAM: 33.6 cm (13¼ in.).
Los Angeles County Museum of Art, The Madina Collection of Islamic Art,
gift of Camilla Chandler Frost; M.2002.1.72.

century, and by the 1260s large-scale production had resumed.[49] There is
only one excavated palace of the Ilkhanid period, at Takht-i Sulaiman,
in northwestern Iran, which preserved extensive evidence of tile decoration
as well as a kiln and a potter's workshop.[50] All other late-thirteenth–
fourteenth-century luster tiles that remain in situ or have a known prove-
nance come from a religious context, mainly funerary monuments or
shrine complexes. Luster star tiles, including those associated with reli-
gious monuments, bear nonfigural and figural ornament and may include
Koranic or purely secular inscriptions or, less commonly, pseudo-inscrip-
tions.[51] Among figural tiles the largest group is decorated with lively,
sometimes humorously depicted animals and birds set within a landscape.
As is typical of the Kashan style, the animals are spotted, without regard
to their natural appearance, as, for example, on a tile with a pleasingly

plump horse amid tall, flowering plants and surrounded by a pseudo inscription in cobalt blue (pl. 18).

Luster-painted pottery traveled far from its origins in ninth-century Iraq, not only to Egypt, Syria, and Iran but also to Islamic Spain by way of North Africa. One important distinction between Spanish and other Islamic lusterwares is that the Spanish potters continued to use earthenware long after fritware had been introduced elsewhere in the Islamic world. While luster painting was practiced in Spain at least by the mid-thirteenth century, the most successful and spectacular examples belong to the period of Nasrid rule (1238–1492), the last Islamic dynasty on the Iberian Peninsula.[52] Vassals of the Christian kingdom of Castile, the Nasrids governed the tiny kingdom of Granada in southeastern Spain. There, Málaga became the first important center of luster production. Málaga wares were widely exported to Christian-held cities, including Manises in Valencia, where they were imitated and eventually surpassed.[53] Valencian lusterware, generally labeled Hispano-Moresque, is still very much within the tradition of Islamic pottery. These wares are typically decorated with interlace, geometric, and floral designs and Arabic inscriptions or pseudo-inscriptions, all taken directly from the repertoire of Islamic art (indeed, many Valencian potters were Muslims).[54] For example, the deep dish in plate 19, with a stylized cobalt-blue tree, pseudo-Arabic inscriptions, and dense, luster-painted background designs, expresses the visual language of Islamic art (pls. 20, 33).

Late Islamic Period

AN AGE OF GREAT EMPIRES, the late Islamic period was dominated by three powerful dynasties: the Safavids in Iran; the Mughals in India; and the Ottomans, the greatest of the late Islamic rulers, who held sway over Anatolia, the Arab lands, and much of eastern Europe. Although the Ottomans already controlled all of Anatolia and parts of eastern Europe prior to their conquest of Constantinople in 1453, the sixteenth century was their golden age. Galvanized by royal patronage, the arts flourished under the Ottomans, whose military incursions into Iran in the later fifteenth and sixteenth centuries led to the appropriation of artists, works of art, and artistic ideas. Ottoman decorative arts and the arts of the book were thereby enriched by the repertoire of floral and vegetal designs first conceived in fifteenth-century Iran.[55] Perhaps even more so than in earlier periods, art was an instrument of dynastic expression.

Chinese pottery had long been appreciated, collected, and imitated in the Islamic world, and this was especially the case at the Ottoman court, where a superb group of Chinese blue-and-white porcelains was assembled to serve as royal tableware.[56] Such Chinese porcelains played a

vital role in the development of the Ottoman ware known as Iznik, after the northwestern Anatolian city where much of this pottery seems to have been produced. Fabricated as architectural revetment as well as tableware, Iznik pottery is one of the most renowned and influential arts of the Ottoman period.[57]

In the late fifteenth century, in emulation of Chinese blue-and-white porcelain, Ottoman potters began producing blue-and-white wares of a quality unequaled in Islamic ceramics. These potters obtained a compact, dense fritware body, which they covered with a white slip to replicate the hard, white body of the Chinese wares. Onto this brilliant white surface they painted floral scrolls, arabesques, and other designs of Chinese or Islamic inspiration in a deep cobalt blue and sometimes in a lighter blue and turquoise, which they then covered with a shiny, colorless glaze.[58] For example, a deep, footed dish dating to the mid-sixteenth century (pl. 38) is decorated with scrolling vines punctuated by floral blossoms loosely based on early-fifteenth-century Chinese porcelains.[59] Vessels of this type, which were made for courtly or affluent urban consumers and served as ordinary tableware, demonstrate the high aesthetic standards of the day.

Toward the mid-sixteenth century the color scheme of Iznik wares expanded dramatically to include not only deep blue and occasionally turquoise but also a bright grass green and an intense red, applied so thickly that it appears in relief.[60] This represents the classic phase of Iznik, famous in Western museum collections and well known to visitors to Istanbul, whose imperial mosques and palaces are richly decorated with tile revetment of this type. Tableware and tiles demonstrate the wide variety of floral ornament used, including lush peonies, plump carnations, hyacinths, and the ubiquitous tulip.

At about the same time that the Iznik palette reached its classic form, the focus of the ceramic industry shifted from tableware to tilework. This shift may have occurred because of the massive building projects undertaken by the court beginning in the 1550s during the reign of Suleyman the Magnificent (r. 1520–66).[61] The first important structure to incorporate a unified decorative scheme of Iznik tiles was the small mosque built by the renowned architect Sinan (ca. 1500–1588) around 1561, for Rustem Pasha, Suleyman's grand vizier and son-in-law.[62]

Secular monuments also demanded tiles, most notably, the Topkapi Saray, or Canon-Gate Palace, both the royal residence and seat of Ottoman government until 1853.[63] Murad III (r. 1574–95), grandson of Suleyman, sponsored a series of additions and renovations to the palace, which is actually a combination of buildings, courts, and gardens, divided among several courtyards and progressing from public to private spaces. Sultan Murad's expansion of the royal quarters, including his bedroom pavilion, took place from 1578 to 1588. A series of magnificent tiles decorated with

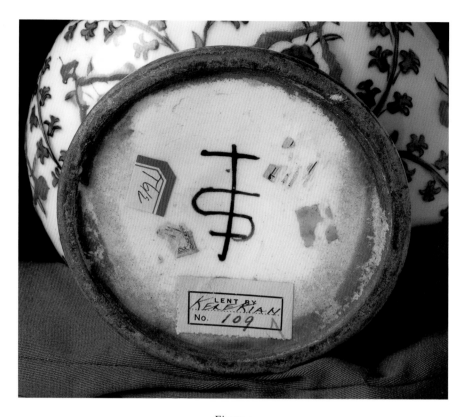

Figure 3
Underside of pierced flower vase (made for the Italian market). Turkey (Iznik),
mid- to late sixteenth century (pl. 40).

blossoming trees, flowers, illusionistically painted imitation brecchia marble, and bold calligraphy embellishes the bedroom pavilion. Many tiles are still in place, while others were likely removed following the devastating fires of the seventeenth century (pl. 41).[64]

The court—the main patron for Iznik wares—also set the price for these tiles, which remained fixed throughout the second half of the sixteenth century and the early seventeenth century, despite staggering inflation.[65] Not surprisingly, this restriction created a conflict between the court's demands for tiles and the Iznik potters' desire for income, often leading to delays in tile production so that other commissions, including those from Europe, beginning in the 1570s, could be satisfied.[66] A table service made to order for the European market could include a coat of arms or other such devices, while a group of pierced flower vases (pl. 40) bears a distinctive black insignia on the base in the form of a long-stemmed cross intersected by the capital letter S (fig. 3). Similar devices occur on maiolica apothecary jars, suggesting that the flowerpots were

perhaps made for an Italian customer.[67] More specifically, this device has been related to the *SP* monogram of Stefano and Piero di Filippo, whose maiolica factory was established on Medici property at Cafaggiolo in 1498 and was in production throughout the sixteenth century.[68] While price fixing and the allure of the free market may have contributed to the decline and eventual demise of the Iznik ceramic industry, the impact and influence of these wares persisted far longer than the zenith of their production in the sixteenth and seventeenth centuries and extended well beyond even the considerable boundaries of the Ottoman Empire.

The evolution and production of much of Islamic art, particularly the types of ceramics and glass considered here, can be linked with the rise of great urban centers. These cities—Baghdad, Cairo, Córdoba, Damascus, Samarqand, Istanbul, to name just a few—each represented a confluence of power (both secular and religious), affluence, and commercial activity. While it would be difficult to project notions of modern consumerism onto the artistic creations of the medieval Islamic world, as has recently been done for the arts of the Italian Renaissance, there are a few points of comparison.[69] Most notable is the lack of a royal or aristocratic aesthetic restricted to a princely class.[70] Rather, the identical designs, visual metaphors, and artistic ideas, often rendered in the same materials, existed at several levels of society, especially for the Muslim urban bourgeoisie. Style and fashion were not a birthright but were directly tied to the purse and the good taste of the consumer, not unlike today.

1. Cyriacus of Ancona (1391–1452) was an Italian traveler and antiquarian who made several trips to Egypt beginning in 1412; the one referred to in this letter took place in 1443 (see Lehmann 1977, 11, where a more complete excerpt from this letter is given).

2. Then known as the Los Angeles County Museum. Hearst acquired the lamp in April 1936 from the well-known European dealer Jacques Seligmann, who had purchased it at the Paris sale of the collection of Lucien Sauphar, one month earlier (see Galerie Charpentier 1936).

3. See Vernoit 1998, 110–15.

4. Ostensibly created to preserve architectural monuments, this was an Egyptian institution, mainly known by its French title, Comité de conservation des monuments de l'art arabe (see Reid 1992, 57–76).

5. Vernoit 1998, 111–13. Also see Carboni 1989, 935–59; and Carboni and Whitehouse 2001, 298–301. For the lamps still in Cairo see Wiet 1929.

6. See Wallis 1894, 3.

7. Masuya 2000, 39–53. Also see Vernoit 1996, 22: 340.

8. Masuya 2000, 50–51.

9. Hadith ("tradition," relating to what the Prophet Muhammad said or did) literature is second in importance only to the Koran. For reference to a somewhat contrary, later legal opinion see Juynboll 1986, 109–10, but also see 112–13. Also see Melikian-Chirvani 1986, 89–106, especially 102–3.

10. Carboni and Whitehouse 2001, 34–35, 199–201. On the technique in general see Caiger-Smith 1985, 24–26.

11. The script seems closest to examples dated to the end of the ninth and the first half of the tenth century in Déroche 1992, encompassing a mixture of the author's "Early Abbasid," nos. 62–65, and "New Style," nos. 75, 79. This is a somewhat earlier dating than in the most recent publication of enameled glass vessel, Carboni and Whitehouse 2001, 218–19, where it is dated late tenth–early eleventh century. Jenkins 1986, 23, proposed an earlier date. Also, see below, n13.

12. Déroche 1992, no. 68 recto. Even if only generically related to the Koranic illumination, the design on the glass vessel seems to fall between the earliest types of foliate decorative bands (Bothmer 1987, 4–20, figs. 17–18) and the more elaborate designs more fully reminiscent of horizontally rendered trees and leafy plants of the tenth to twelfth century (Déroche 1992, nos. 84, 86–87). Also see Jenkins 1985b, 19–23.

13. On this see Jenkins 1985b, 51–56. Also see Grabar 1992, pp. 155ff., where this and related ornaments seem to be firmly rooted in the early Islamic period. For the Koranic illumination see Bothmer 1987, pls. 1–11.

14. Carboni and Whitehouse 2001, 208–20. Also see Carboni 2001b, 51–69, including many fragments.

15. On the latest examples of Persian lusterware from the nineteenth century see Watson 1985, 169–75.

16. For a translation and commentary on this often-quoted text the best source is still Allan 1973, 111–20.

17. Allan 1973, 114.

18. Some relevant literature is summarized in Grube 1976, 342. On the migration of luster painting see Watson 1985, 22–30. Also see Caiger-Smith 1985, 25–30.

19. Caiger-Smith 1985, 29–30. For a more conservative view of the traditional chronology of luster see Watson 1985, 25–26; and especially Jenkins 1980, 335–42.

20. The initial blending and abstraction of the Sassanian crown with a vegetal design occurs as early as the decoration of the Dome of the Rock, Jerusalem, completed in 691 (see Grabar 1973, 58–59; also see Jenkins 1985A, 52–55).

21. First noted in the art-historical literature in Lane 1947A, 10, citing Abu'l-Fadl Muhammad ibn Husayn Bayhaqi (995–1077), the renowned Persian historian.

22. See, for example, Sarre 1925, 54–64, also 65–66; Whitehouse 1969, 46; Scanlon 1970, 81–95; and Whitehouse 1972, 74.

23. Lane 1947A, 13.

24. The first significant production of blue-and-white porcelain in China is generally dated to the second quarter of the fourteenth century, under the Mongol Yuan dynasty (1279–1368), when cobalt from Iran would have been easily obtainable. Significantly, these wares initially seem to have been produced for export, especially to the Islamic world (see, for example, Krahl 1986, 1: 23–63).

25. See, for example, Lane 1947B, 19–30.

26. Allan 1973, 113–14.

27. Watson 1985, 26–28.

28. Watson 1985, 45–67.

29. For a detailed discussion of the motif of the harpy in Islamic art, see Baer 1965.

30. For example, a fragmentary bowl in the Los Angeles County Museum of Art, M.2002.1.187, inscribed with the name of a vizier, a certain Muhammad ibn Abdallah, who has yet to be more specifically identified.

31. See Ettinghausen 1970, 113–31.

32. This material awaits further study and publication but see Porter 1981; Porter and Watson 1987; and Jenkins 1992, where an eleventh-century date for the so-called Tell Minis lusterware is first proposed. Also see Jenkins-Madina forthcoming.

33. Wiet 1929, 143–45, pl. 1. Also see Ward 1998, 30, fig. 9.1.

34. See Kenesson 1998, 46, her type A.

35. The inscription on this object is only partially legible but can be read as "Glory to our master . . . the learned, just king." Such beakers may have served as drinking vessels or they may have been used as lamps (Kenesson 1998, 45).

36. See, for example, Irwin 1986. On the Mamluks as builders, see, for example, Creswell 1959, vol. 2.

37. Perhaps one hundred of these fragile objects have survived to the present day, in part because of their great appeal to Western collectors. In addition to the Museum of Islamic Art, Cairo, major repositories include the Louvre, Paris; Metropolitan Museum of Art, New York; and Victoria and Albert Museum, London. For references to many of these, see Atil 1981, 120–21.

38. For the most recent technical discussion, see Carboni and Whitehouse 2001, 48–52.

39. Many other lamps inscribed with the name of the same emir have survived (see Lamm 1929–30, 1: 449–51, with further additions, in the form of numerous fragments, in Carboni 2001B, 362–65). On Shaykhu's mosque and facing khanaqah, which contains his tomb, see Williams 1993, 60–63.

40. At least two such footed bowls preserve domical covers (see, for example, Carboni and Whitehouse 2001, 268–69).

41. Its presumed function is based on contemporary representations of revelry, where footed drinking bowls are also depicted; see Jenkins 1986, 45. For a list of related bottles, some of which are dated, see Carboni 2001, 366–67.

42. For an enameled and gilded glass example, see Carboni and Whitehouse 2001, 249–52; for a brass canteen inlaid with silver and gold, see Atil, Chase, and Jett 1985, 124–36. There is a thirteenth-century glazed fritware flask with carved decoration and a glazed earthenware canteen of the early Islamic period in the Los Angeles County Museum of Art, M.2002.1.140 and M.2002.1.240, respectively, as well as other unglazed fritware canteens (all unpublished). For the European examples, see Mack 2002, 118–20.

43. For the full inscription and for references to other such signed flasks, see Atil 1981, 191.

44. For relevant excavated material from Syria, see Atil 1981, 190. Also see Riis and Poulsen 1957, 248–58.

45. Textiles may have provided an important means for the dissemination of the new style and motifs that were filtered

through the Iranian world (see, for example, Komaroff and Carboni 2002, cat. no. 71).

46. On Chinese blue-and-white porcelains found in Syria, see Carswell 1972A, 20–25. For finds from Fustat as well as from Syria, see Carswell 1985A, 28–32. Archaeological material from a shipwreck in the Red Sea, including many fourteenth-century blue-and-white porcelains, indicates how such wares reached Syria and Egypt (see Carswell 2000, 175–82).

47. See Carswell 1985, 69 (for a Mamluk bowl found at Hama, Syria) and 125 (for the dish from the Los Angeles County Museum of Art; M.2002.1.72; see here fig. 2, p. 46).

48. Such tiles, preserved in some quantity in many museum collections (British Museum, London; Museum of Islamic Art, Cairo; Los Angeles County Museum of Art; Metropolitan Museum of Art, New York; National Museum, Damascus; and Victoria and Albert Museum, London), are datable to the fifteenth century on the basis of tiles still in situ, as in the Tawrizi mosque complex, Damascus, built before 1430, or tiles known to come from a specific structure, such as the fountain of Sultan Qaytbay (r. 1468–96) (see Carswell 1972B, 99–124).

49. Watson 1985, 123, 131–34.

50. Komaroff and Carboni 2002, 84–102, 263–66.

51. For example, tiles dated 1266–67 from a well-known Shiite shrine, the Imamzada Jo'far, in Damghan are decorated with the lively spotted animals typically associated with Kashan and are inscribed with Persian poetry (see Watson 1985, 134; also Porter 1995, 36).

52. Frothingham 1951, 12–15; and Caiger-Smith 1985, 85. Also see Dodds 1992, 99, where a twelfth-century text referring to the manufacture of luster in Spain is mentioned.

53. Significantly, Málaga wares were also exported to Majorca.

54. Frothingham, 1951, 83–209. Also see Caiger-Smith 1985, 100–103.

55. Generally referred to as the international Timurid style (see Necipoglu 1990, 136–70).

56. For Ottoman archival documentation, see Krahl 1986, especially 1: 65–97. For references to their use at court, see Atasoy and Raby 1989, 14–15, 23, 30.

57. In the sixteenth century Iznik ware was heavily exported to Europe, including Italy, where it was imitated (see Mack 2002, 109), but Iznik ware experienced a second and perhaps still greater phase of admiration and imitation in nineteenth-century Europe (see Hagendorn 1998). Also see Atasoy and Raby 1989, 73.

58. For a detailed technical analysis of these wares, see Atasoy and Raby 1989, 50–69.

59. Such footed dishes bearing flower scrolls continued to be produced into the second half of the sixteenth century, although the floral designs become increasingly stylized (see Atasoy and Raby 1989, 124–25).

60. The color scheme had been modified earlier, in the 1540s, to include sage green and purple—so-called Damascus ware—but this palette seems to have been abandoned by the late 1550s.

61. Atasoy and Raby 1989, 218–21.

62. Denny 1977 remains the best work on this subject.

63. See, for example, Necipoğlu 1991.

64. On Murad III's rebuilding and enlargement of the harem, where the sultan's quarters were also located, see Necipoğlu 1991, 164–75.

65. Atasoy and Raby 1989, 23–25, 274, 278.

66. Necipoğlu 1991, 172, 176, citing specific incidents.

67. See Lane 1957, 58–59. Also see Atasoy and Raby 1989, 264–68; and Mack 2002, 109. On the general topic of trade between the Ottoman Empire and Italy at this time, mainly pertaining to silks and other fabrics, see Inalcik 1994, 218–55. Also see Rogers 2002, 709–36.

68. Atasoy and Raby 1989, 268. For the SP device, see Cora and Fanfani 1982, cat. no. 134. Also see Mack 2002, 106, 206n. 67, where it is noted that the Cafaggiolo factory produced maiolica plates with Ottoman-style floral arabesques, probably during the time of Jacopo di Filippo, son of Stefano, and active ca. 1531–76, roughly overlapping with the period in which the flower vases were made.

69. Goldthwaite 1993.

70. Berens-Abouseif 1999, 162–63.

ونعالج اللغه الزنديه لهذا اوضع علىهما اضما اضا صنع

مز زنايه زرو ملح وبحز الشراب او مز سوز زمان

صوره حكم
عمل ضماد

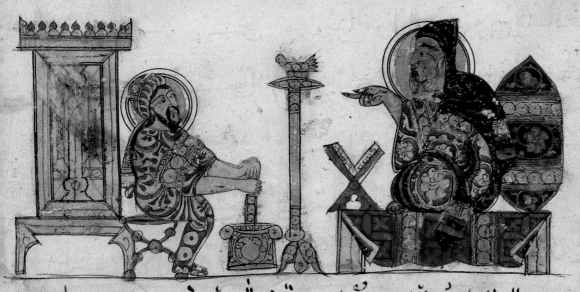

عدى مدقوق او مز زرارود محجون بدقو شعر زخل

وينبغى ان يبطل الجرح ما يح او ما يطبخ ذوايد عا ملسفلون وفعل

مز ورقه ضما اذا اضا ويدخلون الحما را يا ما

ناعا ويسقون هذه الادويه شها بز يكعا بالروميه

حا دوطون وبالسريانيه ركنا والنسون وزا وز د

The World of Islam
and Renaissance Science and Technology

GEORGE SALIBA

The COMMONLY ACCEPTED OPINIONS regarding the scientific and technological contacts between the world of Islam and the Latin West usually emphasize the truly remarkable translation activity that took place between the tenth and thirteenth centuries during which a whole variety of philosophical and scientific works were translated from Arabic into Latin.[1] Even scientific and philosophical works that were originally translated from Greek into Arabic were usually translated once more from Arabic into Latin rather than from the original Greek. The extremely intricate individual and patronized activities that accomplished those feats were mainly centered in cities on the Iberian Peninsula, such as Toledo and Salamanca, and to a lesser extent in Palermo, Sicily, and nearby Italian and other southern European cities. Much scholarship has been devoted to this fertile period of European intellectual history, and some have even gone so far as to designate it as a true "medieval" renaissance.[2] Others have taken notice of the genuine intellectual transformation that occurred during that time and ventured to see in it the beginnings of modern science.[3]

In contrast, very little critical attention has been devoted to the continued contacts between the world of Islam and the Latin West after

Opposite: *Two Physicians Preparing Medicine*. From an Arabic translation of the *Materia Medica* by Dioscorides, 1224. Copied by Abdallah ibn al-Fadl. Opaque watercolor, ink, and gold on paper, 24.6 × 33.1 cm (9⅝ × 13⅛ in.). Washington, D.C., Smithsonian Institution, Freer Gallery of Art, Arthur M. Sackler Gallery; purchase, F1932.20.

the thirteenth century, despite the fact that the Muslim kingdom of Granada continued to flourish in southern Spain until its eventual fall in 1492. The gap between the events of the Middle Ages and the Renaissance has remained so wide as to allow the European Renaissance of the sixteenth and seventeenth centuries to be commonly perceived as a European rediscovery of Greco-Latin antiquity, much to the detriment of, and in opposition to, what was achieved already in medieval times. Eventually scholars identified this later Renaissance period as the true cradle of modernity and, in particular, the birth time of modern science and technology. What contacts with Arabic and Islamic civilization that remained after the thirteenth century were deemed accidental and not as constituent a part of the European Renaissance. This break with medieval thinking, the trend that characterized Renaissance thought, was at the same time perceived as a break with Arabic and Arabism that was central to that same medieval thought.[4]

In what follows I will paint a slightly more nuanced picture and will document a much wider contact between Renaissance Europe and the world of Islam. I will also detail the organic nature of that contact that seems to have prevailed in almost every field of science and certainly the most advanced technological productions and theoretical science. By technological productions and innovations I do not mean the making of paper or the transmission of the knowledge of the navigational compass, for those had already reached Europe during medieval times. I refer rather to the technological transfer of elaborate scientific instruments, such as astrolabes, quadrants, sextants, and the like. Although known, in theory, from classical Greek times, they seem to have made a great impact on Europe through their Islamic manifestations.

Intimate Technological Connections

ROSAMOND MACK's RECENT AND MOST interesting book, *Bazaar to Piazza* (2002), surveys the extensive exchange between the world of Islam and Renaissance Europe in almost every technological domain.[5] Whether in textile, carpets, ceramics, glass, or metalwork, the traffic between the two sides of the Mediterranean (mostly from east to west at first) stretched from the crusading period in the twelfth century all the way to the Renaissance of the sixteenth century and thereafter. In each domain there seems to have been an intimate connection between the two worlds. This dependence relationship extended as far as documenting, in a treaty from the year 1277, even the amount of broken glass loaded in Tripoli on the eastern Mediterranean shore to be shipped to Venice so that it could be used there as raw material for Venetian glassmakers.[6] To the credit of later glassmakers, they managed by the fifteenth

and early sixteenth centuries to master the "sophisticated Syrian techniques and began responding to rising demand, [and] no longer needed to compete with Islamic glass."[7]

Glassmaking, in fact, offers many examples of the continuous contacts between the East and West that extended beyond the mere import and export of finished glass objects. On the level of technique, for example, the fine cutting of colorless crystal glass had already taken place in the eastern Mediterranean as early as the ninth century, and from there it spread to the West.[8] Other cuttings, like facet, relief, and "graving," were all "used on post-Roman glass in the east, but not in the west until reintroduced in the later Middle Ages."[9] Enameling on both colorless and colored glass became first much more prevalent in such Syrian cities as Raqqa and Damascus before the workers of those Eastern glass factories may have begun to migrate westward to "revitalize the western industry at Venice and elsewhere."[10] Like glass cutting, glassblowing, which was very well developed in ancient Roman times, survived only along the eastern Mediterranean after the decline of Rome, and "it was from eastern workers that the Venetians presumably relearned their skilled methods."[11] The same story could be repeated in almost the same details with respect to all other technical aspects of glasswork.

The world of ceramics even introduces elements of clandestine trade to this intriguing story of East-West contacts. "Cobalt blue," for example, which was "known in the east for many centuries, was not used in Italy until early in the fifteenth century.... It was imported as the impure oxide, *zaffre*, from the Levant through Venice (*colore damaschino*, Damascus pigment). Since it was dutiable in many parts, there was considerable smuggling in it."[12] Similarly, the incorporation of tin oxide into the lead-silicate matrix that was applied, first by ninth-century Iraqi potters, to render glass and glazes opaque, in imitation of the creamy porcelain then being imported from China became a widespread technique that flourished first in the East "and particularly in Persia, and [then led] to the profusion of 'majolica' and 'delft' painted wares of Europe from the fourteenth century onwards."[13] The case of cobalt blue brings to mind the "metallic oxides [which] were reduced to very small particles of metal, ...[and thus when applied as] a thick film will look like a solid copper or silver, while a thin film is iridescent and may be gold-coloured."[14] The technique was used in ninth-century Iraq to produce a metallic sheen but was to spread westward by the thirteenth century in what is known as the "Hispano-Moresque wares of north Africa, Malaga, and Valencia... [leading to] similar wares [that] began to be produced in north Italy about 1500."[15] The color glazing and over-glazing techniques involved in tile making "had an effect in Europe comparable to that which they had on pottery. Spain developed a brilliant exotic tile-series, while Italian fifteenth-century tin-glazed tiles have painted arabesques as well

as Renaissance motives, and provided the source of inspiration for this style of refined tile-painting in Flemish, Dutch, French, and English series of the sixteenth and seventeenth centuries."[16]

In the realm of metalwork the trade between the eastern Mediterranean and Europe was so extensive that Syrian and Egyptian metalworkers began to produce objects especially intended for the European market.[17] In the mid-fourteenth century Venetian merchants could place orders with Damascene metalworkers for special types of objects that included European coats of arms.[18] The accommodating eastern Mediterranean artisans could thus demonstrate the flexibility with which they could execute their craft.

Similar documentation bears witness to such interdependence in all other fields of technology and crafts. Thus European everyday life between the tenth and sixteenth centuries, if not beyond, was intimately connected to what was happening in the world of Islam. In matters of luxury and good living Europeans always looked eastward for examples to imitate, despite the fact that on the political level the relationship was mostly adversarial, especially in the later centuries, when the Ottoman Turks were pounding on the fortification walls of major European cities.

Mathematical Technologies and Instruments

YET ANOTHER AREA OF REFINED TECHNOLOGY does not garner the attention it deserves. The replication of scientific instruments not only requires the mastery of artistic techniques but also necessitates scientific precision. Only very educated craftsmen on both sides of the Mediterranean were capable of producing such refined instrumentation. The astrolabe is a perfect example of the ingenious mathematical technique of stereographic projection, that is, the projection that maps the spherical universe on a plane surface while preserving the angles among the celestial circles. Although well developed in classical Greek antiquity, artisans of the Islamic world efficiently combined this highly precise mathematical craft with superb brass metalwork. At first the instrument was usually executed to satisfy a scientific function, and all its lines were drawn with great mathematical precision. With the passage of time it came to be produced as an object of art. Surviving pieces from both sides of the Mediterranean from the ninth to seventeenth centuries, if not beyond, are treasured among the major museums across the world and testify to this exquisite production of fine technology.

From the year 1387, when Geoffrey Chaucer (ca. 1342–1400) wrote his treatise on the astrolabe—in which he acknowledged the Arabic tradition that he was rendering into "naked wordes in Englissh" and the twelfth-century Latin translation of a similar treatise reputedly composed

by Messahalla in Baghdad sometime during the late eighth and early ninth centuries[19]—until the time of the sixteenth-century Flemish astrolabe maker Arsenius (ca. 1575) and thereafter,[20] the astrolabe continued to capture the imagination of the European scientific community. Such derivative instruments, like the navigational sextant and quadrant as well as the universal astrolabes that continued to be produced in most European cities well into the seventeenth and eighteenth centuries, were inspired by their counterparts produced in the eastern Mediterranean, if they were not straightforward copies of the same.

One astrolabe in particular deserves special mention because it tells a story of significant cultural connections that took place in the early sixteenth century. The famous Italian architect Antonio da Sangallo the Younger (1484–1546), who worked on the building of Saint Peter's in Rome as well as on the fortification of the city of Rome, had among his papers, which are still kept at the Uffizi Gallery in Florence, a particular paper that has on its recto the drawing of an astrolabe (fig. 1) and on its verso the uppermost part of the same astrolabe, the rete (fig. 2).[21] This astrolabe would not have been of any special significance had it not been for the fact that, in his meticulousness, Sangallo had also copied down the name of the maker of the astrolabe, which he must have had in his hands. The name of the original maker, copied so faithfully by Sangallo at the edge of the upper-right quadrant on the back of the astrolabe, is Khafif, the apprentice of Ali bin Isa. From textual his-torical sources we know that this Khafif was active in the city of Baghdad toward the mid-ninth century.[22] We are also fortunate to have some of the actual astrolabes he produced; one, in particular, is now kept at the Oxford Museum of the History of Science.[23]

The workmanship of the astrolabe is not of the highest quality when compared to that of surviving specimens of the later centuries and especially to the jewellike objects from Safavid Iran. Since it dates to ninth-century Baghdad, however, it probably represents the earliest surviving piece known. The more curious question is: What was this astrolabe doing at the desk of one of the most famous Italian Renaissance architects and why was it so meticulously copied on paper, including the name of the maker? The rendering of the Arabic lettering in Sangallo's draft reveals a rather mature handwriting, not at all similar to the handwriting of an elementary student of Arabic. To complicate the puzzle, the drawing also includes parts of the astrolabe: the alidade, the pin (usually called "the horse"), and the rete, with a fully drafted copy of the mother of the astrolabe and its back. Other questions come to mind: What was Sangallo's intention in drafting the parts of this astrolabe? Was he planning to pass the draft on to a Florentine artisan and have a duplicate made of it or was he planning to make one himself?

Figure 1
Antonio da Sangallo the Younger (1484–1546).
Drawing (recto) of the back and mater of an astrolabe made by Khafif (fl. 850).
Florence, Galleria degli Uffizi, Gabinetto dei Disegni e Stampe, U1454.

Figure 2
Antonio da Sangallo the Younger.
Drawing (verso) of the rete of an astrolabe made by Khafif (fl. 850).
Florence, Galleria degli Uffizi, Gabinetto dei Disegni e Stampe, U1454.

That an astrolabe would fascinate an architect and a civil engineer like Sangallo is not surprising. We do know, from a tenth-century text written by the famous astronomer Abd al-Rahman al-Sufi (903–986), that such an astrolabe worked like an analog computer and could solve some 380 common mathematical and astronomical problems.[24] In a word, it was the most sophisticated calculating machine of its time. An engineer then would find use for it very much in the same way a modern engineer would find constant use for a pocket calculator or handheld computer. That a Renaissance engineer would resort to such an astrolabe and try to imitate it some seven centuries after it was made, with Arabic markings and all, reveals the extent to which Renaissance men of science were dependent on the scientific technology of the world of Islam. Sangallo must have thought of this particular astrolabe as the epitome of a sophisticated scientific machine despite the fact that it was by then seven centuries old and other examples far surpassed it in beauty, precision, and comprehensiveness. Just like his contemporary metalworkers, glassmakers, and textile manufacturers, Sangallo too was trying to imitate the kind of technology that he thought was superior to what was then available in Europe.

From Scientific Technology to Theoretical Science

THE HEAVY DEPENDENCE ON SOPHISTICATED Islamic scientific instruments during the European Renaissance is further corroborated by a more general dependence on the theoretical scientific results that were also produced in the world of Islam and continued to be sought by European scientists during the Renaissance and thereafter. Recent research in the history of Islamic and Renaissance astronomy, for example, which has been systematically pursued over the past fifty years or so, has now demonstrated a similar intimate interdependence in matters of the highest theoretical sophistication. Other fields, like mathematics and medicine, to say nothing of major philosophical movements like Averroism (reading Aristotle through the commentaries of Averroës) and the like, also indicate an intellectual environment, in Renaissance Italy in particular, that was heavily influenced by what had been going on in the Islamic world more than two or three centuries earlier.

The astronomical field is of particular importance here, not only because astronomy was always thought of as the queen of the sciences in premodern times (a well-acknowledged competitor to theology, which was similarly crowned at times) but because it became, at the hands of Copernicus (Mikołaj Kopernik, 1473–1543) and his followers, the cause célèbre after which the scientific renaissance is conceptualized as a scientific revolution.[25] From that perspective astronomical research marked a watershed within which was born modern science and modernity itself.

If one could demonstrate that Renaissance scientists, like their contemporary artisans, had recourse to results that were already forged in the Islamic world, then one could move a step closer to understanding the true nature of the European Renaissance as an intellectual temperament promoting the free exchange of ideas that were still being sought in the world of Islam.

The astronomical research pursued in the world of Islam between the ninth and the sixteenth century focused on three main issues. First, it sought to correct the basic astronomical values inherited from earlier civilizations, particularly those derived from classical Greek antiquity. Second, it attempted to conceptualize the very foundation of science, and astronomy in particular, in a novel way by insisting that various scientific disciplines be logically consistent within themselves and across disciplines. In Islamic civilization it was no longer sufficient to produce a chain of mathematical reasoning, say, like Euclidean geometry, and in the process involve absurd physical concepts that would no longer make sense in the field of physics. For example, a mathematically defined sphere must have certain mathematical properties that could be readily translated into a sphere, which then could be exemplified by an actual physical ball. Both spheres must have a fixed point at their center when they revolve around an axis that passes through that center, and both spheres must have outer surfaces equidistant from that center.

The third object of Islamic astronomy was to construct a comprehensive new astronomy to replace the inherited Greek form, which proved early on to be technically flawed. It was no longer sufficient to concoct astronomical theories to predict the positions of the planets or explain celestial phenomena, as was done by the best Greek astronomers. The new requirement instead demanded that one find an astronomy whose predictions were physically, mathematically, and cosmologically consistent.

The results achieved by astronomers working in the Islamic world were passed on to the Latin West either directly, through medieval translations, or in other ways. In correcting the basic Greek astronomical values it became apparent that all observational values, no matter how precise, would necessarily imply approximations that would become exaggerated with time. For example, the canonical Greek astronomical text of Ptolemy (Claudius Ptolemaeus, fl. 150) stipulated that the fixed stars moved with respect to the point of the vernal equinox at the rate of one degree for every one hundred years. Some seven hundred years later astronomers of ninth-century Baghdad measured the same fixed stars with respect to the vernal equinox and quickly discovered that the stipulated Greek motion was much too slow and that those stars moved at a faster rate, of one degree per about seventy years. Some refer to this phenomenon as the "phenomenon of precession," which gave rise to the much-admired song "Aquarius" in the popular musical *Hair* of the 1960s.

The inclination of the ecliptic, reflected in the slanting of the earth's axis that causes the four annual seasons, is now taught to be 23½ degrees, a value that was also established in ninth-century Baghdad, and not the Greek value that was about half a degree too large. Several other such basic values were freshly determined in early Islamic times, and all have become an integral part of the world heritage, thanks to their being incorporated in such fundamental Latin texts that were either translated or freshly produced in the late Middle Ages and the Renaissance.

The more fundamental changes introduced by the astronomers of the Islamic civilization were of the second type, namely, the "consistency project." Astronomers working in the Islamic domain were no longer satisfied with simply correcting basic observational values but went further, looking for the reasons that caused those errors in the first place and to question the very foundation of the schematic presuppositions governing the conceptual scheme of Greek astronomy itself. Errors caused by faulty observational methods or faulty instruments were not as serious as those contradictions resulting from the conceptual assumptions regarding the very nature of Greek astronomy.

To illustrate: when Ptolemy found that the solar apogee (the point in the celestial sphere where the sun looked to be at its farthest distance from the earth or, conversely, when the earth was at the farthest distance from the sun) was fixed in the celestial space, only to be contradicted by ninth-century astronomers who found it to be in motion, the conclusion drawn by those astronomers was that Ptolemy had followed the wrong observational method by trying to observe the declination of the sun at the solstices, around June 21 and December 21. This difficulty is easily appreciated when we notice that the sun rises and sets almost at the same points along the horizon for several days before and after the solsticial dates of June 21 and December 21. If one were to determine the exact time at which the sun would actually cross the solsticial point, there would be a span of several days from which to choose and thus the precision would be highly compromised. An alternative method developed in ninth-century Baghdad yielded much better results. It depended on observing the sun's declination during the middle of the seasons, when the change from one day to the next would be much easier to pinpoint. More accurate values for the motion of the solar apogee and for solar eccentricity, yielding in turn a better solar equation, were thus produced.

All these corrections and modifications were thought to be much less important than the fundamental disagreement found in the Greek sources between the accepted observational results and the cosmological presuppositions used to account for those results and to predict their recurrence. The geometric models used by Ptolemy to "explain" the observational phenomena of the planets and predict their positions for any time and place stipulated the kind of mathematical entities, such as

spheres and circles, that did not consistently preserve their mathematical properties when they were thought of as physical objects. In other words, the cosmological foundations of Greek astronomy—stipulating that all observable celestial phenomena were generated by physical celestial spheres made of the simple element ether, in the mathematical representations of those celestial spheres developed by Ptolemy, spheres that rotated in place at uniform speeds around axes that did not pass through their centers—were physically impossible.

To astronomers working in the Islamic domain, this fundamental contradiction between the presupposed cosmological physical foundation and representative mathematical geometry was much more serious than a simple mistake due to a faulty instrument or a bad method of observation. It was tantamount to asking someone to accept, for all sorts of reasons that were very well argued by Aristotle (384–322 B.C.) and his followers, that the universe was composed of celestial ethereal spheres and then turning around and speaking about those spheres as if they did not have the same mathematical properties as a sphere. It was as absurd as talking about spheres by drawing triangles to illustrate the argument. Great efforts were spent to rid the Greek astronomical tradition of such glaring faults. These attempts all focused on elaborating on the nature of those fallacies and then analyzing their significance in the field of astronomy.

The first efforts at correcting them were similar to the modifications deemed essential for arriving at basic astronomical values: to expose each contradiction and keep intact the rest of the cosmological structure. Further, the boundary conditions—the observational realities to be considered—were not neglected. A whole body of literature thus emerged in which expository treatises detailing the faults of Greek astronomy became a genre by themselves. Only then did attempts at taking bolder steps begin to be made. In creating alternative theories astronomers of the Islamic world found their greatest successes. One astronomer after another would venture to develop mathematical models that would depict the observational behavior of the planets, just as they were observed in Greek and early Islamic times, but at the same time preserve all the mathematical and physical properties of the constituent units of which the models were composed. Physical spheres remained to be represented by mathematical spheres, with properties befitting a genuine sphere.

During that process of creating new astronomical theories, new mathematical theorems were developed to refine the representational tools of the mathematical models, specifically so that the models would not contradict the physical cosmological presuppositions. One such theorem, developed by the astronomer Nasir al-Din al-Tusi (1201–1274), proved to be extremely influential in the development of Arabic and Renaissance astronomy. The treatise in which the theorem was formally stated by

NOTES

1. See, for example, Haskins 1960.

2. Haskins 1927.

3. Lindberg 1992.

4. For a quick reference to the disputes between the "humanists" and the "Arabists" in Renaissance and post-Renaissance Europe, see Toomer 1996, 15–16, and nn. 6–77.

5. Mack 2002.

6. Mack 2002, 113.

7. Mack 2002, 123.

8. See Harden 1956, 327.

9. Harden 1956, 341.

10. Harden 1956, 328.

11. Harden 1956, 337.

12. See Pope 1956, 301.

13. Pope 1956, 302.

14. Pope 1956, 304.

15. Pope 1956, 304.

16. Pope 1956, 307.

17. Mack 2002, 140.

18. Mack 2002, 140.

19. Both works formed the subject of Gunther 1929, vol. 5.

20. For a beautiful collection of such instruments from both sides of the Mediterranean and a discussion of their interconnections, see Turner 1985.

21. Gabinetto dei disegni e stampe, U1454.

22. See Ibn al-Nadim 1970, 2: 671.

23. No. 57-84/155.

24. Sufi 1962.

25. See Kuhn 1957 and Kuhn 1962.

26. In particular, see Arabic manuscript, Vat. Arabo 319 flyleaf, and folios 28 verso and 29 recto (for an edited translation see Ragep 1993).

27. For the detail of the correspondence between Kepler and Maestlin, see Grafton 1973, 523–50.

28. Levi Della Vida 1939, esp. 307.

29. There are several biographies of Postel, the most readable being Weill 1987.

30. The article appears on the Internet at http://www.columbia.edu/~gas1/ project/visions/case1/sci.1.html.

31. See Ursula Weisser, "Avicenna: Influence on Medical Studies in the West." In *Encyclopedia Iranica*, 3: 107–10, esp. 109, col. 2.

32. *Ambrosii Calepini Bergomatis Lexicon, mvlto, qvam vspiam hactenus excusum fuerit, locupletius. Quid uero hac in editione nostra praestiterit uigilitantia, sequens docebit pagina Calepinvs lector* (1538).

33. As quoted by Nallino 1911, 222.

Overleaf: *Parade of the Guild of Potters* from the *Surname-i Hümayan*, ca. 1582 (detail). Istanbul, Topkapi Palace Museum Library, inv. H.1344, fol. 405b.

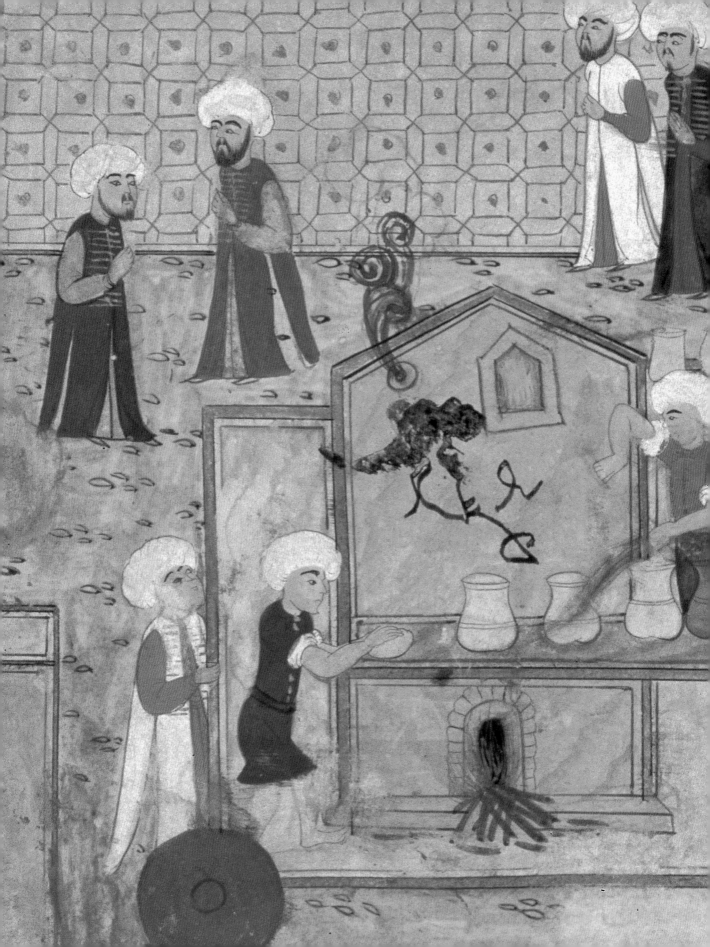

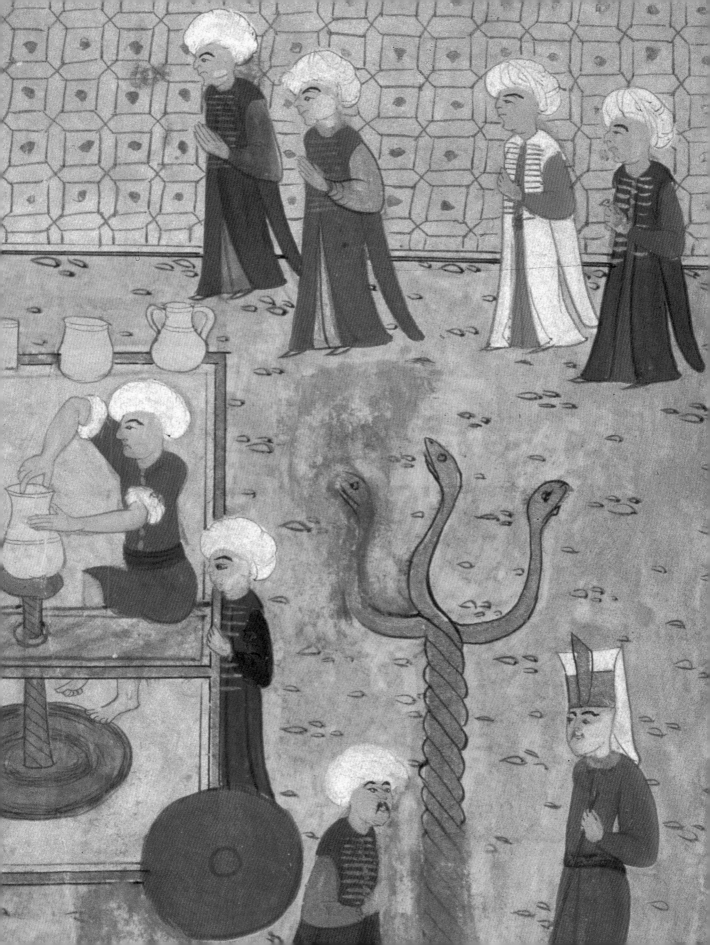

Blown Glass

PLATE 1

Aryballos

Byzantium or late Roman Empire,
sixth or seventh century. Free-blown
glass with applied ornament,
H: 8.6 cm (3⅜ in.). Los Angeles,
J. Paul Getty Museum, 71.AF.80.

PLATE 2

Bottle

Islamic Middle East, ninth century.
Free-blown glass, H: 15.2 cm (6 in.).
Los Angeles, J. Paul Getty Museum,
78.AF.23.

PLATE 3

Container in the form of an animal

Probably Iran, tenth or
eleventh century. Free-blown glass
with applied ornament, 8.1 ×
5.6 × 11.1 cm (3³⁄₁₆ × 2³⁄₁₆ × 4³⁄₈ in.).
Los Angeles County Museum
of Art, gift of Varya and Hans
Cohn; M.88.129.187.

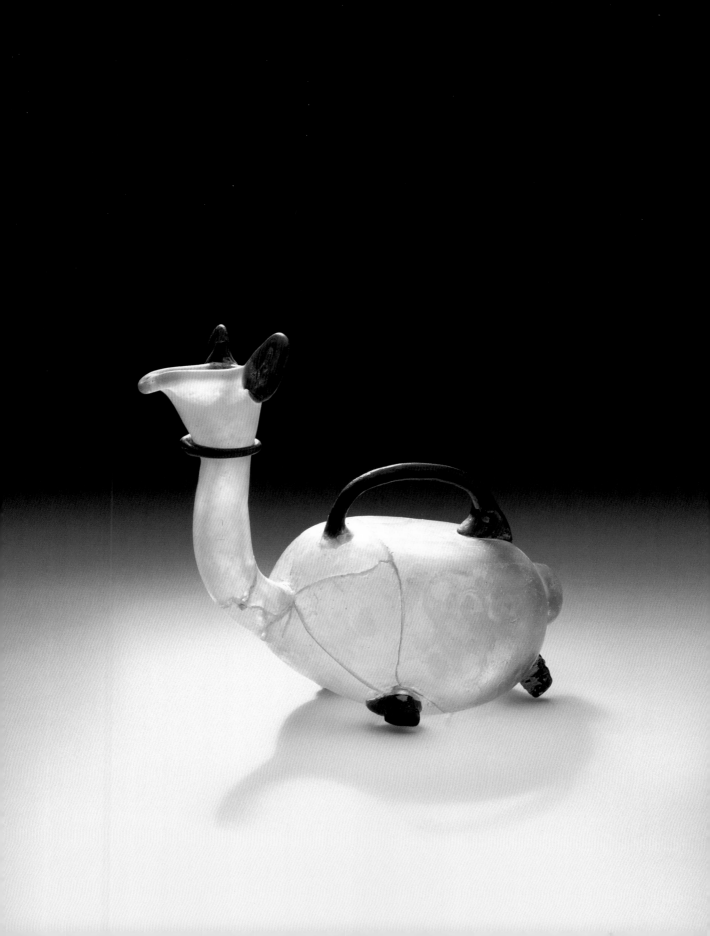

Islamic Enameled and Gilded Glass

Tazza

Egypt or Syria, late thirteenth
to early fourteenth century. Glass
painted with polychrome enamels
and gold, H: 33.3 cm (13⅛ in.),
DIAM: 24.8 cm (9¾ in.). New York,
The Metropolitan Museum of
Art, Gift of Mr. and Mrs. V. Everit
Macy, 1923; 23.189.

Photograph © 1994
The Metropolitan Museum of Art.

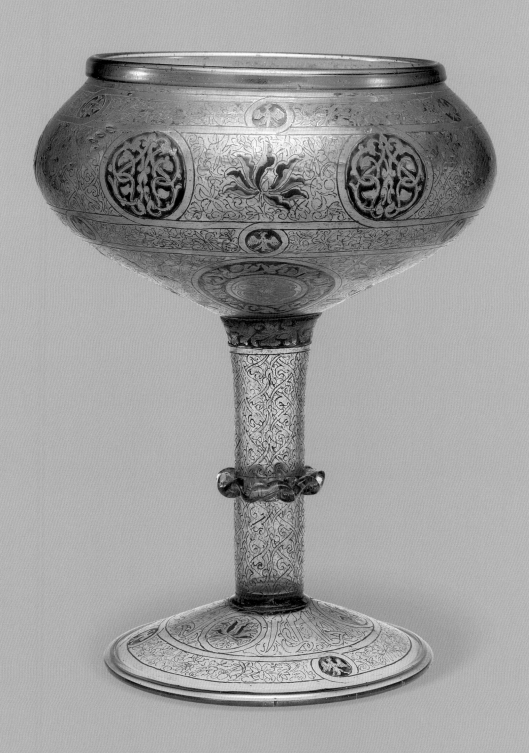

PLATE 5

Bottle

Egypt or Syria, 1300–1350. Free-blown
and tooled gilt and enameled glass,
H: 50.2 cm (19¾ in.). New York,
The Metropolitan Museum of Art,
Purchase, Joseph Pulitzer Bequest,
1936; 36.33.

Photograph © 2003
The Metropolitan Museum of Art.

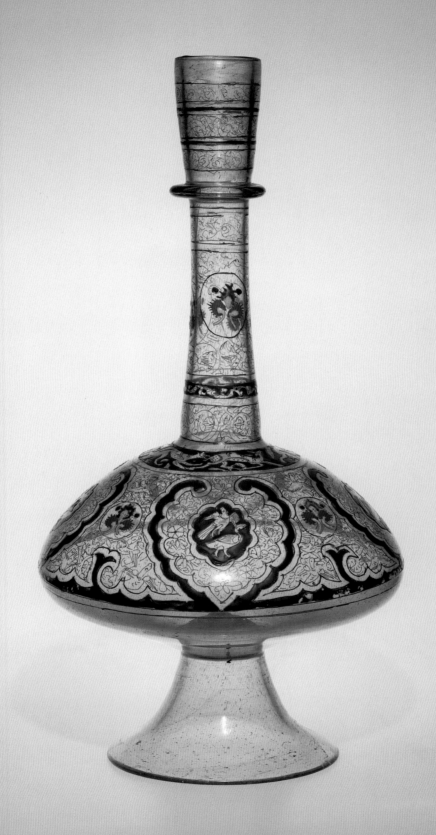

PLATE 6

Lamp

Egypt or Syria, mid-fourteenth
century. Enameled and gilded glass,
34.6 × 28.6 cm (13⅝ × 11¼ in.).
Los Angeles County Museum
of Art, William Randolph Hearst
Collection; 50.28.4.

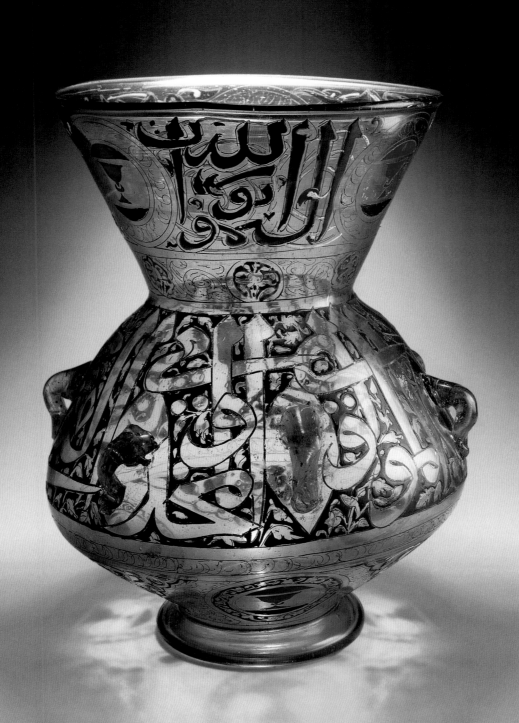

Islamic Influences on Italian Glass

PLATE 7

Beaker

Syria, first half of thirteenth century.
Enameled glass, 8.1 × 8.7 cm
(3³⁄₁₆ × 3⅞ in.). Los Angeles County
Museum of Art, gift of Varya and
Hans Cohn; M.88.129.196.

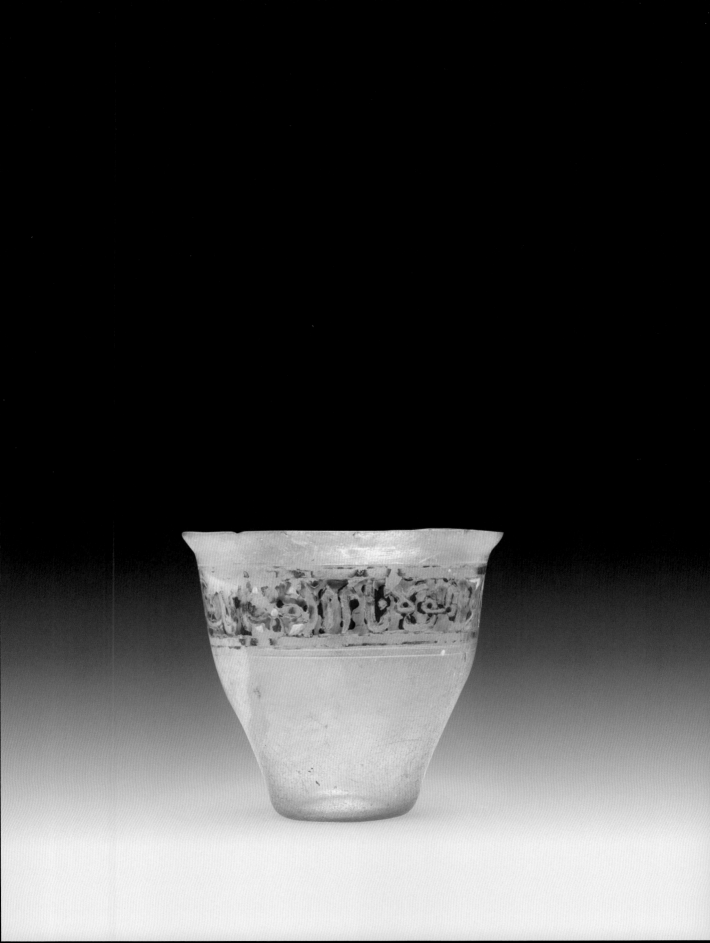

PLATE 8

Goblet

Italy (Murano), late fifteenth or
early sixteenth century.
Free-blown colorless glass with gold
leaf and enamel decoration,
H: 13.5 cm (5⁷⁄₁₆ in.). Los Angeles,
J. Paul Getty Museum, 84.DK.540.

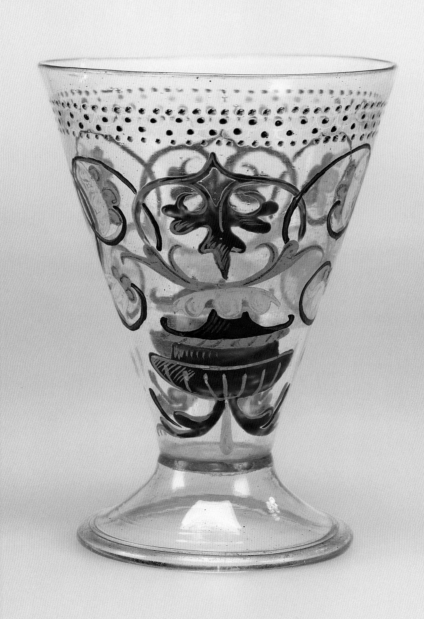

PLATE 9

Hexagonal tile

Syria, first half of fifteenth century.
Underglaze-painted composite
ceramic body, w: 16.8 cm (6⅝ in.).
New York, The Metropolitan
Museum of Art, x.228.1.

Photograph © 1982
The Metropolitan Museum of Art.

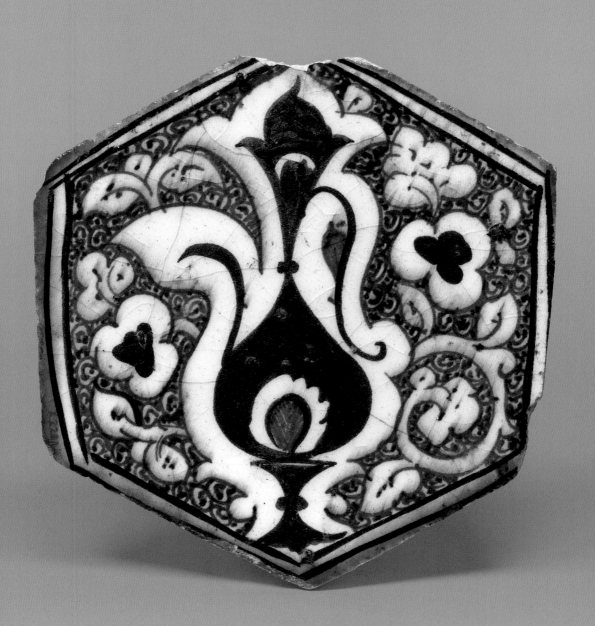

PLATE 10

Ewer

Italy (Murano), ca. 1500. Enameled
and gilded glass, H: 25.4 cm (10 in.).
Los Angeles County Museum of Art,
purchased with funds provided by
William Randolph Hearst, Decorative
Arts Council Acquisition Fund,
Decorative Arts Curatorial Discre-
tionary Fund, Mrs. Lorna Hammond,
the William A. Dinneen Estate,
Mrs. Edwin Greble, Mrs. Walter
Barlow, Mr. and Mrs. Allan C.
Balch Collection, Allan Ross Smith,
and Mrs. Wesley Heard; 84.2.1.

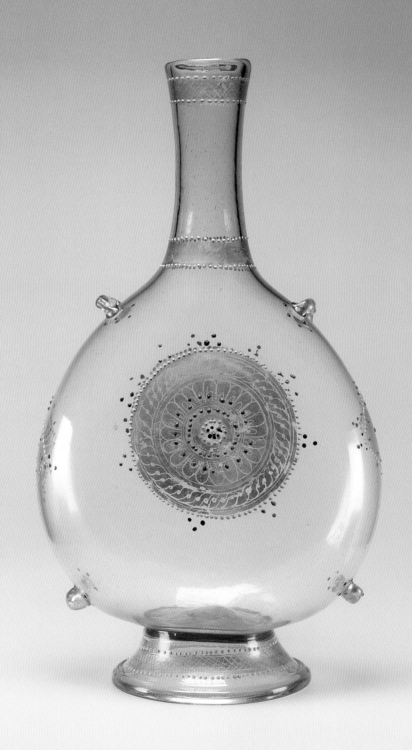

PLATE 13

Pilgrim flask

Italy (Murano), 1500–1520. Free-
blown colorless glass with gold leaf,
enamel, and applied decoration,
H: 31.3 cm (12 5/16 in.). Los Angeles,
J. Paul Getty Museum, 84.DK.539.

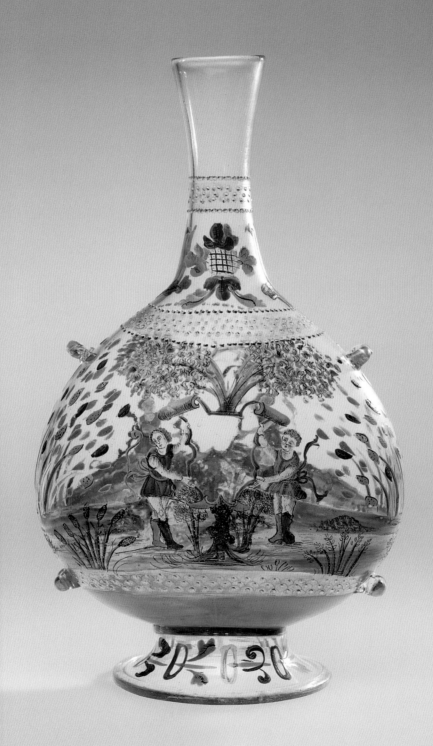

Tin Glaze and Luster on Ceramics

Bowl

Iraq, ninth or tenth century.
Tin-glazed and stain-painted
earthenware, DIAM: 20.3 cm (8 in.).
Los Angeles County Museum
of Art, The Nasli M.
Heeramaneck Collection, gift
of Joan Palevsky; M.73.5.133.

PLATE 15

Bowl with Kufic inscription

Probably Egypt or Syria, ninth or tenth
century. Free-blown and stained bluish-
colorless glass, tooled on pontil, H: 10.7 cm
(4 ³⁄₁₆ in.). New York, The Metropolitan
Museum of Art, Purchase, Rogers Fund
and Gifts of Richard S. Perkins, Mr. and
Mrs. Charles Wrightsman, Mr. and Mrs.
Louis E. Seley, Walter D. Binger, Margaret
Mushekian, Mrs. Mildred T. Keally, Hess
Foundation, Mehdi Mahboubian, and Mr.
and Mrs. Bruce J. Westcott, 1974; 1974.74.

Photograph © 2000
The Metropolitan Museum of Art.

PLATE 16

Bowl

Iraq, ninth century. Luster-painted
earthenware, DIAM: 24.1 cm
(9½ in.). Los Angeles County
Museum of Art, The Nasli M.
Heeramaneck Collection,
gift of Joan Palevsky; M.73.5.238.

PLATE 17

Plate with harpy

Iran, late twelft or early thirteenth
century. Luster-painted fritware,
DIAM: 17.2 cm (6 in.). Los Angeles
County Museum of Art, The
Nasli M. Heeramaneck Collection,
gift of Joan Palevsky; M.73.5.269.

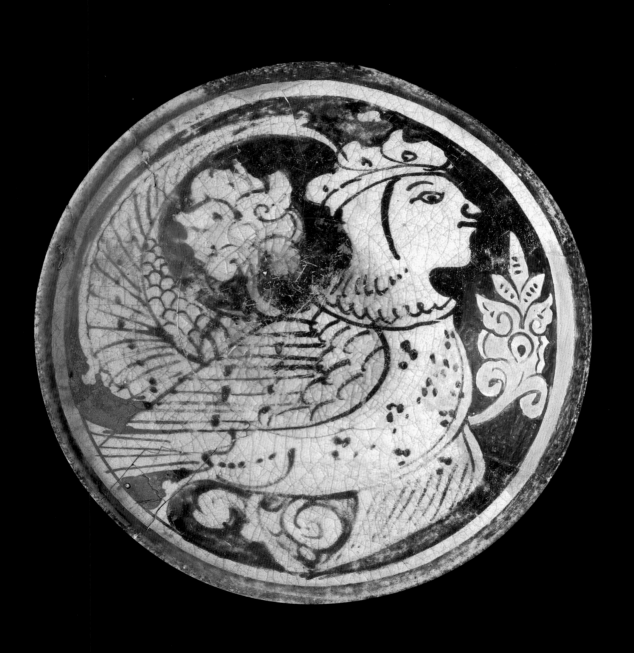

PLATE 18

Star tile with horse

Iran, fourteenth century. Luster-painted fritware, DIAM: 21 cm (8½ in.). Los Angeles County Museum of Art, The Nasli M. Heeramaneck Collection, gift of Joan Palevsky; M.73.5.377.

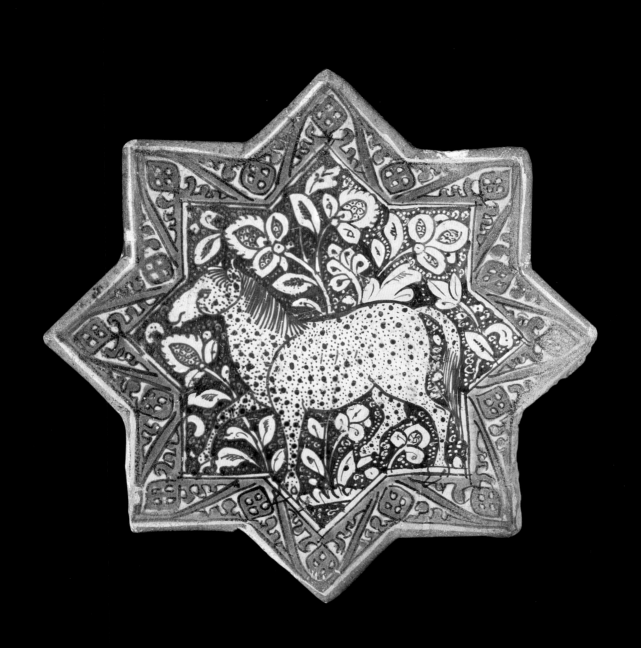

PLATE 19

Deep dish

Spain (Valencia region), ca. 1430.
Glazed and stain- and luster-painted
earthenware, DIAM: 45.1 cm
(17¾ in.). New York, The Metro-
politan Museum of Art, The
Cloisters Collection, 1956; 56.171.162.

Photograph © 1982
The Metropolitan Museum of Art.

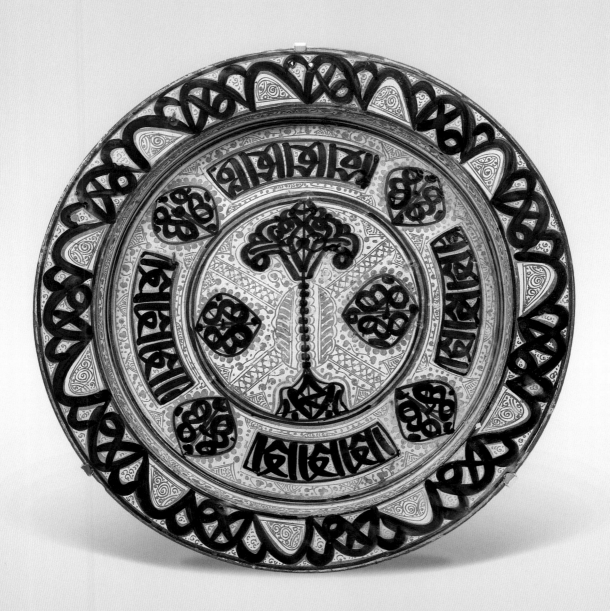

PLATE 20

Basin

Spain (Valencia region, Manises),
mid-fifteenth century. Tin-glazed
and luster-painted earthenware,
DIAM: 49.5 cm (19½ in.).
Los Angeles, J. Paul Getty Museum,
85.DE.441.

PLATE 21

Plate with coat of arms

Italy (Deruta), ca. 1520. Tin-glazed
and luster-painted earthenware,
DIAM: 41.3 cm (16¼ in.). Los Angeles
County Museum of Art, William
Randolph Hearst Collection; 50.9.25.

PLATE 22

Condiment dish

Italy (Faenza, luster-painted
in Gubbio), ca. 1560. Tin-glazed
and luster-painted earthenware,
7.3 × 19.7 cm (2⅞ × 7¾ in.).
Los Angeles County Museum
of Art, William Randolph Hearst
Collection; 50.9.1.

PLATE 23

Pilgrim flask with marine scenes

Fontana workshop (possibly
Orazio, 1510–1570), Italy (Urbino),
ca. 1565–70. Tin-glazed earthenware,
H: 43.5 cm (17⅛ in.). Los Angeles,
J. Paul Getty Museum, 84.DE.119.1–2.

PLATE 26

Jar with a Kufic pattern

Italy (Montelupo), mid-fifteenth
century. Tin-glazed earthenware,
H: 18.1 cm (7⅛ in.). Los Angeles,
J. Paul Getty Museum, 84.DE.96.

PLATE 29

Bowl with facing birds

Iran, early thirteenth century.
Luster-painted fritware,
DIAM: 16.5 cm (6½ in.). Los Angeles
County Museum of Art, The
Nasli M. Heeramaneck Collection,
gift of Joan Palevsky; M.73.5.214.

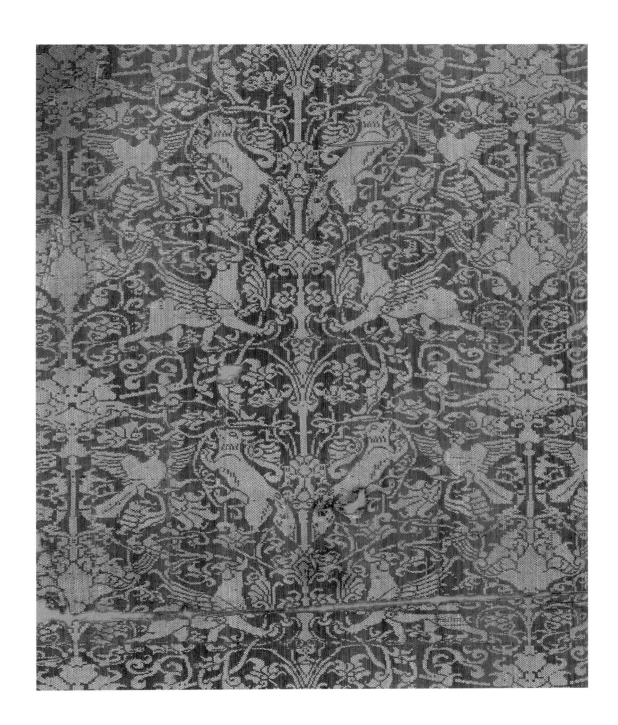

PLATE 31

Relief-blue jar with harpies and birds

Probably the workshop of Piero
di Mazzeo (b. 1377), Italy (Florence
or possibly Siena), ca. 1420–30.
Tin-glazed earthenware,
H: 31.1 cm (12¼ in.). Los Angeles,
J. Paul Getty Museum, 85.DE.56.

The *Albarello*

Albarello

Syria (Raqqa), late twelfth or early
thirteenth century. Luster-painted
fritware, H: 25.2 cm (9⅞ in.).
New York, The Metropolitan
Museum of Art, H. O. Havemeyer
Collection, Gift of Horace
Havemeyer, 1948; 48.113.12.

Photograph © 2003
The Metropolitan Museum of Art.

Albarello

Spain (Valencia), first half of
fifteenth century. Tin-glazed and
luster-painted earthenware,
H: 29.5 cm (11⅝ in.). New York,
The Metropolitan Museum of Art,
The Cloisters Collection, 56.171.92.

Photograph © 2003
The Metropolitan Museum of Art.

Albarello

Italy (Umbria), early fifteenth
century. Tin-glazed earthenware,
H: 25.4 cm (10 in.). New York,
The Metropolitan Museum of Art,
The Cloisters Collection, 46.85.9.

Photograph © 2003
The Metropolitan Museum of Art.

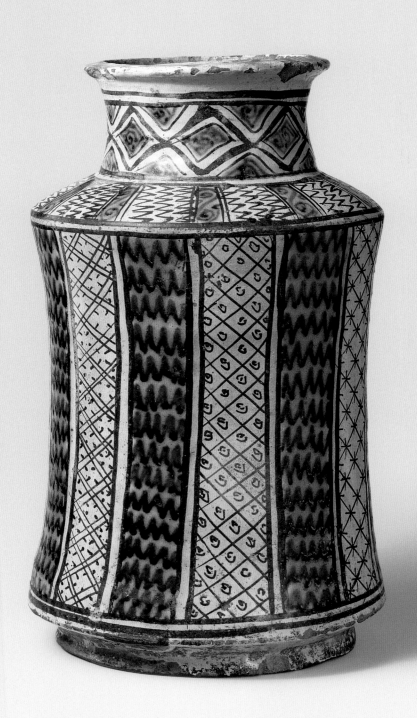

PLATE 35

Jar with foliate decoration

Italy (Montelupo), mid-fifteenth
century. Tin-glazed earthenware,
H: 18.6 cm (7 5/16 in.). Los Angeles,
J. Paul Getty Museum, 84.DE.100.

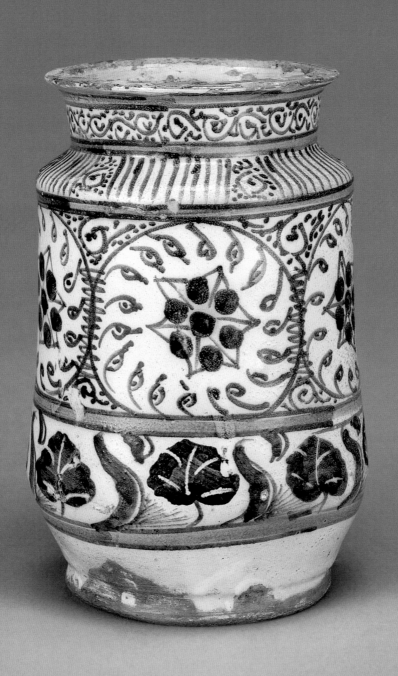

Jar with a woman and geese

Italy (Deruta or Montelupo),
early sixteenth century. Tin-glazed
earthenware, H: 24.8 cm (9¾ in.).
Los Angeles, J. Paul Getty Museum,
84.DE.112.2.

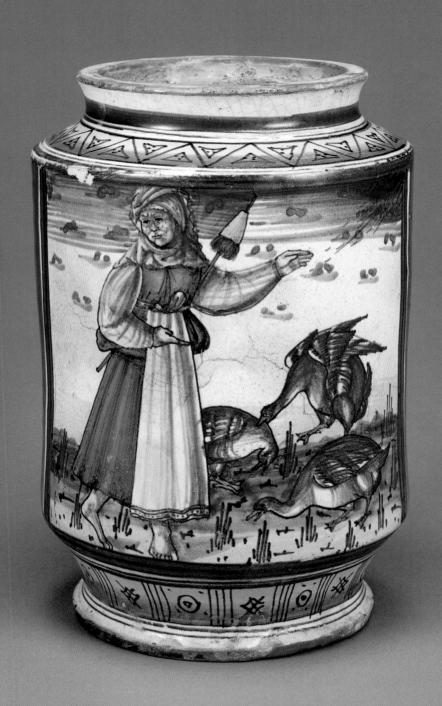

The Influence of Porcelain

PLATE 37

Blue-and-white bowl with flowers

China, Ming dynasty, Xuande
mark and period (1426–1435).
Porcelain, DIAM: 20.7 cm (8⅛ in.).
Sunrider International, Chen Art
Gallery.

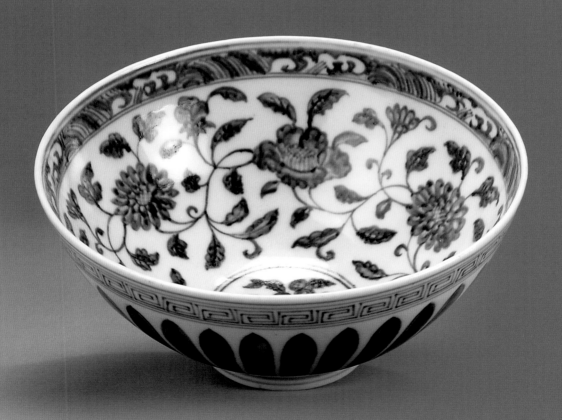

PLATE 38

Footed dish

Turkey (Iznik), mid-sixteenth
century. Underglaze-painted fritware,
DIAM: 33 cm (13 in.). Los Angeles
County Museum of Art, The
Edward Binney, 3rd, Collection of
Turkish Art at the Los Angeles
County Museum of Art; M.85.237.82.

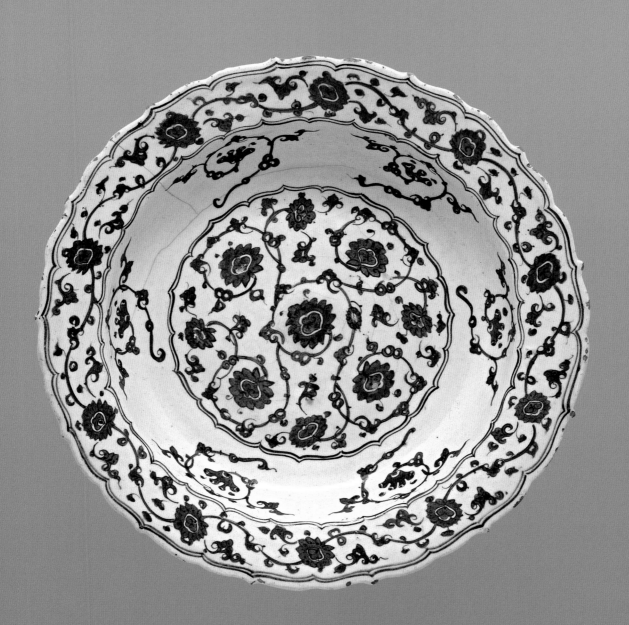

PLATE 39

Blue-and-white dish with a merchant ship

Italy (Cafaggiolo), ca. 1510.
Tin- glazed earthenware,
DIAM: 24.3 cm (9⁹⁄₁₆ in.).
Los Angeles, J. Paul
Getty Museum, 84.DE.109.

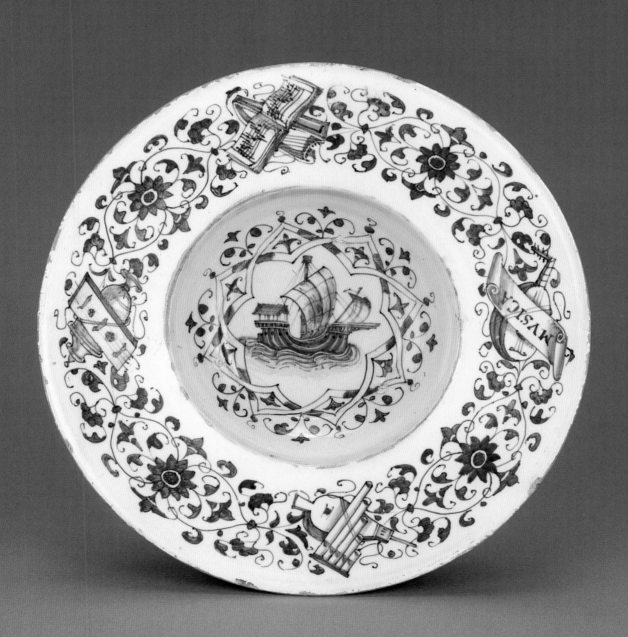

PLATE 40

Pierced flower vase
(made for the Italian market)

Turkey (Iznik), mid- to late sixteenth century. Underglaze-painted fritware, 13.3 × 15.2 cm (5¼ × 6 in.).
Los Angeles County Museum of Art, The Madina Collection of Islamic Art, gift of Camilla Chandler Frost; M.2002.1.16.

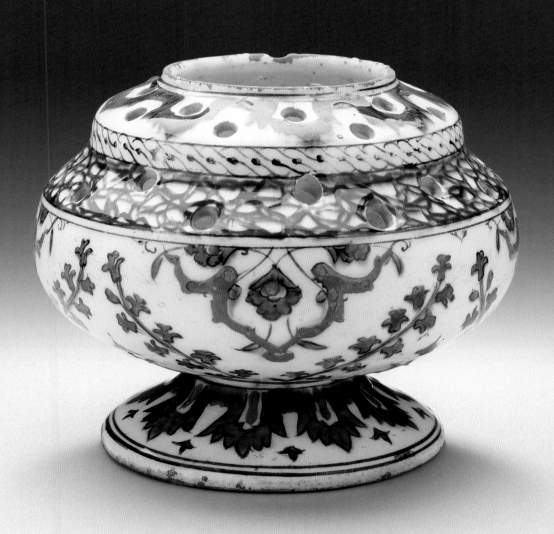

PLATE 41

Tile

Turkey (Iznik), ca. 1580–90.
Underglaze-painted fritware,
28.6 × 30.5 cm (11¼ × 12 in.).
Los Angeles County Museum
of Art, Purchased with funds
provided by Phil Berg; M.2000.31.

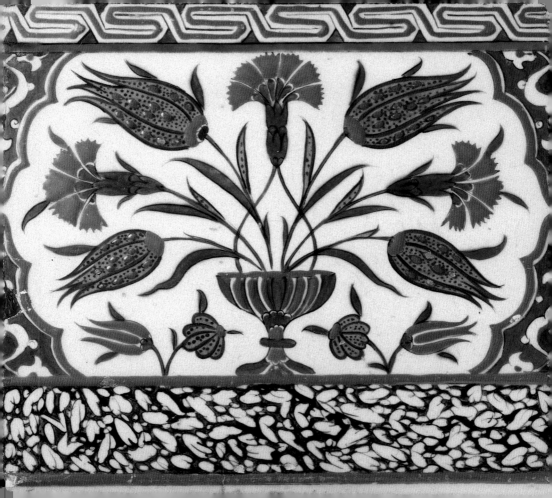

PLATE 42

Pilgrim flask

Italy (Florence), 1580s. Soft-paste
porcelain, H: 26.4 cm (10⅜ in.).
Los Angeles, J. Paul Getty Museum,
86.DE.630.

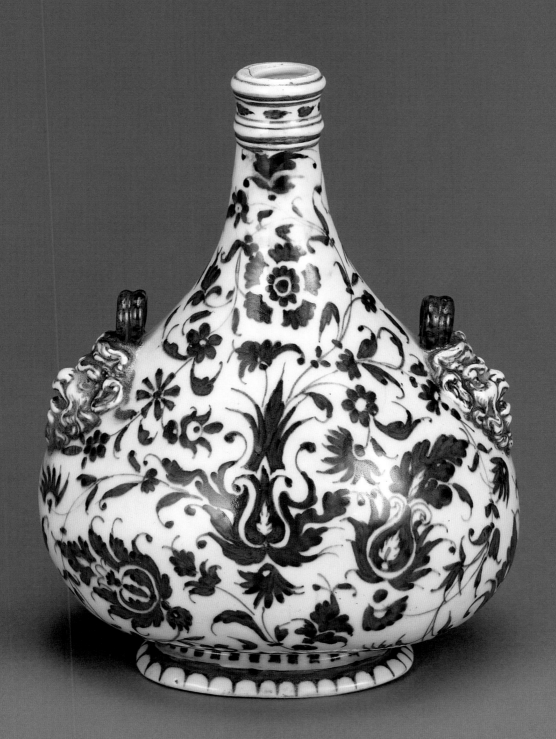

Glossary

ABBASID A dynasty of rulers based in Baghdad that claimed descent from Abbas (d. 653), the uncle of the Prophet Muhammad, and ruled the Islamic empire from 750 to 1258.

AL-ANDALUS The Arabic name for Andalusia, the area of Spain that came under Muslim rule from 711 to 1492. In the eleventh century, when Christians began to reconquer the Iberian Peninsula, the term referred to the southernmost region that remained under Muslim rule. It may mean "country of the Vandals" since this Germanic people invaded Spain at the end of Roman rule in the fifth century.

ASSYRIA A kingdom of northern Mesopotamia that became one of the great empires of the ancient Middle East from the fourteenth to the seventh century B.C.

AVERROISM Teachings of the later Middle Ages and Renaissance that were inspired by the Muslim philosopher Averroës (1126–1198), whose commentaries on Aristotle's works emphasized the superiority of reason and philosophy over knowledge founded on faith.

AYYUBID A dynasty founded by Saladin (1137/38–1191) — a Muslim military hero of Kurdish origin — that ruled Egypt and Syria from 1169 to 1250, displacing the Fatimids.

BYZANTIUM The eastern portion of the Roman Empire that survived after the disintegration of the western portion and dates from the foundation of Constantinople in 330 until its capture by the Ottomans in 1453.

CALIPH A ruler of the Muslim community. The term derives from the Arabic *khalifa*, meaning "deputy or successor" to the Prophet Muhammad.

CRUSADES The military expeditions undertaken by the Western Christian authorities against Muslim powers in the eleventh, twelfth, and thirteenth centuries in order to take control of Jerusalem and other places associated with the earthly life of Jesus Christ.

FATIMIDS A dynasty that ruled in North Africa and then Egypt and Syria from 909 to 1171. The dynasty took its name from Fatimah (ca. 605–633), daughter of the Prophet Muhammad, from whom Fatimids claimed descent.

HADITH Source of religious and moral guidance, it is an account of the traditions or sayings of Muhammad and his companions.

ILKHANID A dynasty of Mongol origin that ruled large parts of western Asia, including Iran, Iraq, Khorasan, the Caucasus, and parts of Asia Minor from 1256 to 1335, bringing to an end the Abbasid caliphate. Genghis Khan's grandson, Hülegü (ca. 1217–1265), led the conquest and assumed the title Il-Khan, meaning "lesser" Khan (or Mongol ruler), subordinate to the "great" Khan, who ruled in China.

ISLAM Arabic word meaning "submission" (to God); it is the name for the religion founded under the leadership of the Prophet Muhammad. The term also denotes the Muslim community.

KORAN Also spelled Qu'ran, it is the holy book of Islam and is regarded as the word of God as revealed to the Prophet Muhammad. Its name derives from Arabic for "recitation."

LEVANT From the French *lever*, "to rise," as in sunrise, it denotes the direction east and historically means the countries along the eastern shores of the Mediterranean, specifically Syria, Palestine, and the coastlands of Asia Minor.

MAMLUK From the Arabic word for "slave"; a member of one of the armies of slaves that gained political control and ruled Egypt and Syria under the Ayyubid sultanate from 1250 to 1517.

MESOPOTAMIA The area that lies literally "between the [Tigris and Euphrates] rivers" in southwest Asia, extending from the mountains of eastern Asia Minor to the Persian Gulf.

MIHRAB Prayer niche in a mosque or other religious structure, indicating the direction of prayer, toward Mecca.

MONGOL A tribe originating in the eastern part of modern-day Mongolia and sharing a language and nomadic tradition. In the thirteenth and fourteenth centuries, under the leadership of Genghis Khan (1155/62–1167–1227) and his successors, Mongols controlled an area extending from northern China to Hungary.

MOSQUE Any place or open area for Muslim communal worship. Outside the mosque is an elevated place where a crier, or muezzin, calls the community to prayer five times a day.

MUGHAL A Mongol dynasty founded by a descendant of Timur (Tamerlane) (1336–1405) and Genghis Khan, which ruled most of northern India from 1526 to 1858.

MUSLIM Literally "one who submits," the term refers to someone who adheres to the faith of Islam.

NASRID Last of the Muslim dynasties in Spain, it ruled the Kingdom of Granada from 1238 to 1492.

OTTOMAN An empire created by Turkish tribes that ruled Anatolia and then much of eastern Europe and the Middle East from 1281 to 1984. It was a particularly powerful state during the fifteenth and sixteenth centuries.

QAJAR A dynasty founded by a leader of the Turkmen Qajar tribe—a tribe that spoke a particular Turkic language and ruled Iran from 1794 to 1925.

SAFAVID A dynasty that ruled Iran from 1502 to 1736 and helped create the awareness of a unified nation.

SASANIANS Pre-Islamic dynasty that ruled greater Iran from 224 to 651; it was named after Sasan (fl. first century A.D.), an ancestor of the first Sasanid leader.

SULTAN Originally referring to a moral or spiritual authority, the term came to denote a political or governmental leader of an Islamic state.

TIMURID Central Asian dynasty founded by the sons of Timur (Tamerlane) (1336–1405) that ruled Iran and parts of central Asia from the late fourteenth century to 1506.

TURK Originally, any of various Asian peoples speaking a Turkic language in a region extending from the Black Sea to western China.

UMAYYAD The first Islamic dynasty that ruled in the Middle East, from 661 to 750. With the overthrow of the Umayyads by the Abbasid dynasty in 750, a member of the Umayyad dynasty fled Damascus for Córdoba to establish a branch of Umayyad rule in Spain from 756 to 1031.

References

AGUZZI AND BLAKE 1978
Aguzzi, Francesco, and Hugo Blake. "I bacini della facciata di S. Lanfranco a Pavia: La prima maiolica arcaica?" 11–27. *Atti del XI Convegno internazionale della ceramica*. Albisola.

ALINARI 1991
Alinari, Alessandro. "Un piatto araldico ed il problema dei lustri a Cafaggiolo." *CeramicAntica* 1, no. 3 (March): 24–33.

ALLAN 1973
Allan, James. "Abu'l-Qasim's Treatise on Ceramics." *Iran* 11: 111–20.

ATASOY AND RABY 1989
Atasoy, Nurhan, and Julian Raby. *Iznik: The Pottery of Ottoman Turkey*, ed. Yanni Petsopoulos. London.

ATIL 1981
Atil, Esin. *Renaissance of Islam: Art of the Mamluks*, exh. cat. Washington, D.C.

ATIL, CHASE, AND JETT 1985
Atil, Esin, W. T. Chase, and Paul Jett. *Islamic Metalwork in the Freer Gallery of Art*, exh. cat. Washington, D.C.

AULD 1991
Auld, Sylvia. "The Mamluks and the Venetians: Commercial Interchange: The Visual Evidence." *Palestine Exploration Quarterly* (July–December): 84–102.

BAER 1965
Baer, Eva. *Sphinxes and Harpies in Medieval Islamic Art: An Iconographical Study*. Jerusalem.

BALLARDINI [1938] 1975
Ballardini, Gaetano. *La maiolica italiana: Dalle origini alla fine del cinquecento*. Reprint. Faenza.

BAROVIER MENTASTI 1982
Barovier Mentasti, Rosa. *Mille anni di arte del vetro a Venezia*, exh. cat. Venice.

BAUMGARTNER AND KRUEGER 1988
Baumgartner, Erwin, and Ingeborg Krueger. *Phönix aus sand und ashe: Glas des Mittelalters*, exh. cat. Munich.

BEAN 1982
Bean, John Michael William. "The Black Death: The Crisis and Its Social and Economic Consequences." In *The Black Death: The Impact of the Fourteenth-Century Plague*, ed. Daniel Williman, 23–33. New York.

BECK, MANOUSSACAS, AND PERTUSI 1977
Beck, Hans-Georg, Manoussos Manoussacas, and Agostino Pertusi. *Venezia, centro di mediazione tra Oriente e Occidente, secoli XV–XVI: Aspetti e problemi*. Vol. 1. Florence.

BEHRENS-ABOUSEIF 1999
Behrens-Abouseif, Doris. *Beauty in Arabic Culture*. Princeton.

BERTI 1997
Berti, Fausto. *Le ceramiche da mensa dalle origini alla fine del XV secolo*. Vol. 1 of *Storia della ceramica di Montelupo: Uomini e fornaci in un centro di produzione dal XIV al XVIII secolo*. 3 vols. Montelupo Fiorentino.

BERTI 1998
Berti, Fausto. *Le ceramiche da mensa dal 1480 alla fine del XVIII secolo*. Vol. 2 of *Storia della ceramica di Montelupo: Uomini e fornaci in un centro di produzione dal XIV al XVIII secolo*. 3 vols. Montelupo Fiorentino.

BERTI AND TONGIORGI 1973
Berti, Graziella, and Liana Tongiorgi. "Bacini ceramici su alcune chiese della campagna Lucchese." *Faenza* 59: 4–15.

BERTI AND TONGIORGI 1981A
Berti, Graziella, and Liana Tongiorgi. *I bacini ceramici del duomo di San Miniato*. Genoa.

BERTI AND TONGIORGI 1981B
Berti, Graziella, and Liana Tongiorgi. *I bacini ceramici medievali delle chiese di Pisa*. Rome.

BERTI AND TONGIORGI 1985
Berti, Graziella, and Ezio Tongiorgi. *Ceramiche importate dalla Spagna nell'area pisana dal XII al XV secolo*. Florence.

BERTIN AND GUBEL 1998
Bertin, Charles, and Eric Gubel. *En Syrie: Aux origines de l'écriture*, exh. cat. Turnhout, Belgium.

BOTHMER 1987
Bothmer, Hans-Casper Graf von. "Architektur-bilder im Koran." *Pantheon* 45: 4–20.

BRANCA 1986
Branca, Vittore, ed. *Mercanti scrittori: Ricordi nella Firenze tra medioevo e rinascimento*. Milan.

BRAUDEL 1982
Braudel, Fernand. *Civilization and Capitalism, Fifteenth–Eighteenth Century*. Vol. 2, *The Wheels of Commerce*. New York.

BUCKTON 1984
Buckton, David, ed. *The Treasury of San Marco, Venice*, exh. cat. Milan.

BUKOVINSKÁ, FUČIKOVÁ, AND KONEČNÝ 1984
Bukovinská, Beket, Eliska Fučiková, and Lubomír Konečný. "Zeichnungen von Giulio Romano und seiner Werkstatt in einem vergessenen Sammelband in Prag." In *Jahrbuch der Kunsthistorischen Sammlungen in Wien*, 80: 61–186. Vienna.

BUORA 1997
Buora, Maurizio. "Una produzione artigianale di un vetraio a Sevegliano [Agro di Aquileia, Italia Settentrionale] nel IV sec. d.c." *Journal of Glass Studies* 39: 23. Corning, N.Y.

BUSTI 1995
Busti, Giulio. "Riverberi del terzo fuoco: La tecnica del lustro." *CeramicAntica* 5, no. 5 (May): 48–53.

CAIGER-SMITH 1973
Caiger-Smith, Alan. *Tin-Glaze Pottery in Europe and the Islamic World: The Tradition of One Thousand Years in Maiolica, Faience, and Delft-Ware*. London.

CAIGER-SMITH 1985
Caiger-Smith, Alan. *Lustre Pottery: Technique, Tradition, and Innovation in Islam and the Western World*. London.

CARBONI 1989
Carboni, Stefano. "Le 'lampade egizie' della Murano ottocentesca." In *La conoscenza dell'Asia e dell'Africa in Italia nei secoli XVIII e XIX*, ed. Ugo Marazzi, 3, no. 2: 935–59. Naples.

CARBONI 1998
Carboni, Stefano. "Gregorio's Tale; Or, Of Enamelled Glass Production in Venice Painted Glass." In *Gilded and Enamelled Glass from the Middle East*, ed. Rachel Ward, 101–6. London.

CARBONI 2001A
Carboni, Stefano. *Glass of the Sultans*, exh. cat. New York.

CARBONI 2001B
Carboni, Stefano. *Glass from Islamic Lands: The al-Sabah Collection*. London.

CARBONI 2001C
Carboni, Stefano. "Painted Glass." In *Glass of the Sultans*, exh. cat., ed. Stefano Carboni and David Whitehouse, 199–207. New York.

CARBONI AND WHITEHOUSE 2001
Carboni, Stefano, and David Whitehouse, eds. *Glass of the Sultans*, exh. cat. New York.

CARSWELL 1972A
Carswell, John. "China and the Near East: The Recent Discovery of Chinese Porcelain in Syria." In *The Westward Influence of the Chinese Arts from the Fourteenth to the Eighteenth Century*, ed. William Watson, 20–25. London.

CARSWELL 1972B
Carswell, John. "Six Tiles." In *Islamic Art in the Metropolitan Museum of Art*, ed. Richard Ettinghausen, 92–124. New York.

CARSWELL 1985
Carswell, John. "Blue and White Porcelain in China." In *Blue and White: Chinese Porcelain and Its Impact on the Western World*, exh. cat., by John Carswell, 13–26. Chicago.

CARSWELL 1993
Carswell, John. "'The Feast of the Gods'—The Porcelain Trade between China, Istanbul, and Venice." *Asian Affairs* (June): 180–85.

CARSWELL 1999
Carswell, John. "China and the Middle East." *Oriental Art* 45, no. 1: 2–14.

CARSWELL 2000
Carswell, John. *Blue and White: Chinese Porcelain around the World*. London.

CARSWELL 2002
Carswell, John. "Free for All: Blue-and-White in 1500." *Oriental Art* 48, no. 5: 10–19.

CASALI 1987
Casali, Mariarosa Palvarini Gobio. *La ceramica a Mantova*. Ferrara.

CHAUDHURI 1985
Chaudhuri, K. N. *Trade and Civilisation in the Indian Ocean: An Economic History from the Rise of Islam to 1750*. Cambridge.

CLIFFORD AND MALLET 1976
Clifford, Timothy, and J. V. G. Mallet. "Battista Franco as a Designer for Maiolica." *Burlington Magazine* 118: 387–410.

CONSTABLE 2003
Constable, Olivia Remie. *Housing the Stranger in the Mediterranean World: Lodging, Trade, and Travel in Late Antiquity and the Middle Ages.* Cambridge.

CONTADINI 1999
Contadini, Anna. "Artistic Contacts: Current Scholarship and Future Tasks." In *Islam and the Italian Renaissance,* ed. Charles Burnett and Anna Contadini, 1–60. London.

CORA 1973
Cora, Galeazzo. *Storia della maiolica di Firenze e del Contado: Secolo XIV e XV.* 2 vols. Florence.

CORA AND FANFANI 1982
Cora, Galeazzo, and Angiolo Fanfani. *La maiolica di Cafaggiolo.* Florence.

COUTTS 2001
Coutts, Howard. *The Art of Ceramics: European Ceramic Design, 1500–1830.* New Haven.

COX-REARICK 1999
Cox-Rearick, Janet, ed. *Giulio Romano, Master Designer,* exh. cat. New York.

CRAY 1998
Cray, W. Patrick. "Glassmaking in Renaissance Italy: The Innovation of Venetian Cristallo." *Journal of Minerals, Metals, and Materials Society* 50, no. 5 (May): 14–19.

CRESWELL 1959
Creswell, K. A. C. *The Muslim Architecture of Egypt.* Vol. 1, *Ikshidids and Fatimids, 939–1171 A.D.*; vol. 2, *Ayyubids and Early Bahrite Mamluks, 1171–1326 A.D.* Oxford.

CROWE 1977
Crowe, Yolande. "Early Islamic Pottery and China." *Transactions of the Oriental Ceramic Society* 41: 263–75.

CURATOLA 1993
Curatola, Giovanni, ed. *Eredità dell'Islam: Arte islamica in Italia,* exh. cat. Milan.

DENNY 1977
Denny, Walter. *The Ceramics of the Mosque of Rustem Pasha and the Environment of Change.* New York.

DÉROCHE 1992
Déroche, François. *The Abbasid Tradition: Quran of the Eighth and the Tenth Centuries.* Vol. 1, *The Nasser D. Khalili Collection of Islamic Art.* New York.

DODDS 1992
Dodds, Jerrilynn D., ed. *Al-Andalus: The Art of Islamic Spain,* exh. cat. New York.

DODWELL 1961
Dodwell, C. R., ed. *Theophilus: De diversis artibus.* London.

DURAND 1992
Durand, Jannic. "Verrerie," 93. In *Byzance: L'art byzantin dans les collections publiques françaises,* exh. cat. Paris.

ETTINGHAUSEN 1970
Ettinghausen, Richard. "The Flowering of Seljuk Art." *Metropolitan Museum Journal* 3: 113–31.

FEHÉRVÁRI 2000
Fehérvári, Géza. *Ceramics of the Islamic World in the Tareq Rajab Museum.* London.

FIOCCO AND GHERARDI 1994
Fiocco, Carola, and Gabriella Gherardi, eds. *La ceramica di Deruta dal XIII al XVIII secolo.* Perugia.

FIOCCO AND GHERARDI 2002
Fiocco, Carola, and Gabriella Gherardi. "Maestro Giorgio: Il lustro di Gubbio e l'istoriato del ducato di Urbino." In *La maiolica italiana del cinquecento: Il lustro eugubino e l'istoriato del ducato di Urbino,* ed. Gian Carlo Bojani, 61–68. Florence.

FONTANA 1989
Fontana, Maria Vittoria. "Rapporti artistici fra ceramica islamica e ceramica veneta fra il quattrocento e il seicento." In *Arte veneziana e arte islamica: Atti del primo simposio internazionale sull'arte veneziana e l'arte islamica,* ed. Ernst J. Grube, 125–46. Venice.

FOUREST 1987
Fourest, Henry-Pierre. "Influence de l'Orient sur la majolique." In *Art, objets d'art, collections: Études sur l'art du moyen âge et de la Renaissance, sur l'histoire du gout et des collections. Hommage à Hubert Landais,* 160–63. Paris.

FRANÇOIS 1997
François, Véronique. "Céramiques importées à Byzance: Une quasi-absence." *Byzantinoslavica* 58, no. 2: 387–404.

FRANCOVICH AND GELICHI 1984
Francovich, Riccardo, and Sauro Gelichi. *La ceramica spagnola in Toscana nel bassomedioevo.* Florence.

FROTHINGHAM 1951
Frothingham, Alice W. *Lustreware of Spain.* New York.

GABRIELI AND SCERRATO 1979
Gabrieli, Francesco, and Umberto Scerrato. *Gli Arabi in Italia: Cultura, contatti, e tradizioni.* 2d ed. Milan.

GALERIE CHARPENTIER 1936
Galerie Charpentier. *Collection Lucien Sauphar, première vente: Sièges et meubles du XVIII^e siècle estampillés de Nogaret, H. Jacob, Brizard, Hansen, Héricourt, etc.; collection de verrerie ancienne; art arabe, Venise, Allemagne, etc.; paravents en laque de Coromandel; importants bijoux, collier, bagues, broche, bracelets, sautoirs.* Paris.

GELICHI 1992
Gelichi, Sauro. "La ceramica spagnola nell Italia tardo-medievale: Riflessioni su alcune tipologie." In *XXXIX Corso di cultura sull'arte ravennate e bizantina*, 359–70. Ravenna.

GIACOMOTTI 1974
Giacomotti, Jeanne. *Catalogue des majoliques des Musées nationaux*. Paris.

GIAMPAOLA AND ROMANO 1998
Giampaola, Daniela, and Rosa Romano. *Dal castello alla città: Ricerche, progetti, e restauri in Castel Nuovo*. Naples.

GOLDTHWAITE 1989
Goldthwaite, Richard. "The Economic and Social World of Italian Renaissance Maiolica." *Renaissance Quarterly* 42, no. 1: 1–32.

GOLDTHWAITE 1993
Goldthwaite, Richard. *Wealth and the Demand for Art in Italy, 1300–1600*. Baltimore.

GRABAR 1973
Grabar, Oleg. *The Formation of Islamic Art*. New Haven.

GRABAR 1992
Grabar, Oleg. *The Mediation of Ornament*. Princeton.

GRAFTON 1973
Grafton, Anthony. "Michael Maestlin's Account of Copernican Planetary Theory." *Proceedings of the American Philosophical Society* 117 (1973): 523–50.

GRIFFITHS, HANKINS, AND THOMPSON 1987
Griffiths, Gordon, James Hankins, and David Thompson, trans. *The Humanism of Leonardo Bruni: Selected Texts*. New York.

GRUBE 1976
Grube, Ernst J. *Islamic Pottery of the Eighth to the Fifteenth Century in the Keir Collection*. London.

GRUBE 1994
Grube, Ernst J. *Cobalt and Lustre: The First Centuries of Islamic Pottery*. London.

GUNTHER 1929
Gunther, R. T. *Early Science in Oxford*. Vol. 5, *Chaucer and Massahalla on the Astrolabe*. Oxford.

HAGENDORN 1998
Hagendorn, Annette. *Auf der Suche nach dem neuen Stil: Der Einfluss der osmanischen Kunst auf die europäische Keramik im 19. Jahrhundert*, exh. cat. Berlin.

HARDEN 1956
Harden, Donald B. "Glass and Glazes." In *A History of Technology*, ed. Charles Singer, pp. 311–46. Vol. 2, *The Mediterranean Civilizations and the Middle Ages, c. 700 B.C. to 1500 A.D.*, Oxford.

HARDEN 1987
Harden, Donald B. *Glass of the Caesars*, exh. cat. Milan.

HARDING AND MICKLEWRIGHT 1997
Harding, Catherine, and Nancy Micklewright. "Mamluks and Venetians: An Intercultural Perspective on Fourteenth-Century Material Culture in the Mediterranean." *RACAR, Revue d'art canadienne* 24, no. 2: 47–66.

HASKINS 1927
Haskins, Charles Homer. *The Renaissance of the Twelfth Century*. Cambridge.

HASKINS 1960
Haskins, Charles Homer. *Studies in the History of Mediaeval Science*. New York.

HASSAN AND HILL 1986
Hassan, Ahmed Y. al-, and Donald R. Hill. *Islamic Technology: An Illustrated History*. Cambridge.

HEIKAMP 1986
Heikamp, Detlef. *Studien zur mediceischen Glaskunst: Archivalien, entsurfszeichnungen Gläser und Sherben*. Florence.

HENDERSON 1985
Henderson, Julian. "The Raw Materials of Early Glass Production." *Oxford Journal of Archaeology* 4, no. 3: 267–91.

HERALD 1981
Herald, Jacqueline. *Renaissance Dress in Italy, 1400–1500*. London.

HESS 1999
Hess, Catherine. *Maiolica in the Making: The Gentile/Barnabei Archive*. Los Angeles.

HESS 2002
Hess, Catherine. *Italian Ceramics: Catalogue of the J. Paul Getty Museum Collections*. Los Angeles.

HOLMAN 1997
Holman, Beth, ed. *Disegno: Italian Renaissance Designs for Decorative Arts*, exh. cat. Dubuque.

IBN AL-NADIM 1970
Ibn al-Nadim, Muhammad ibn Ishaq. *The Fihrist of al-Nadim: A Tenth-Century Survey of Muslim Culture*, tr. Bayard B. Dodge. 2 vols. New York.

INALÇIK 1994
Inalçik, Halil. *An Economic and Social History of the Ottoman Empire*. Vol. 1, *1300–1600*. Cambridge.

IRWIN 1986
Irwin, Robert. *The Middle East in the Middle Ages: The Early Mamluk Sultanate, 1250–1382*. London.

JACOBY 1993
Jacoby, David. "Raw Materials for the Glass Industry of Venice and the Terraferma." *Journal of Glass Studies* 35: 65–90.

JARDINE 1996
Jardine, Lisa. *Worldly Goods: A New History of the Renaissance*. New York.

JENKINS 1980
Jenkins, Marilyn. "Medieval Maghribi Luster-Painted Pottery." In *La céramique médiévale en Méditerranée occidentale, X^e–XV^e siècles*, 335–42. Paris.

JENKINS 1985A
Jenkins, Marilyn. "Islamic Art in the Metropolitan Museum of Art." *Arts and the Islamic World* 3, no. 3: 51–56.

JENKINS 1985B
Jenkins, Marilyn. "A Vocabulary of Umayyad Ornament." In *Masahif San'ca*, exh. cat., 19–23. Kuwait.

JENKINS 1986
Jenkins, Marilyn. *Islamic Glass: A Brief History*. New York, 1986. Reprinted from *The Bulletin of the Metropolitan Museum of Art* (Fall).

JENKINS 1992
Jenkins, Marilyn. "Early Medieval Pottery: The Eleventh Century Reconsidered." *Muqarnas* 9: 56–66.

JENKINS-MADINA FORTHCOMING
Jenkins-Madina, Marilyn. "Raqqa Revisited: The Ceramics of the Saljuq Successor States."

JOURNAL OF CHRISTOPHER COLUMBUS [1893] 1971
The Journal of Christopher Columbus (during His First Voyage, 1492–93), tr. Clements R. Markham. Reprint. New York.

JUYNBOLL 1986
Juynboll, G. H. A. "The Attitude towards Gold and Silver in Early Islam." In *Pots and Pans: A Colloquium on Precious Metals and Ceramics in the Muslim, Chinese, and Graeco-Roman Worlds*, ed. Michael Vickers, 107–15. Oxford.

KALAVREZOU 1997
Kalavrezou, Ioli. "Luxury Objects." In *The Glory of Byzantium: Art and Culture of the Middle Byzantine Era, A.D. 843–1261*, exh. cat., ed. Helen C. Evans and William D. Wixom, 219–23. New York.

KENESSON 1998
Kenesson, Summer S. "Islamic Enamelled Beakers: A New Chronology." In *Gilded and Enamelled Glass from the Middle East*, ed. Rachel Ward, 45–49. London.

KINGERY 1993
Kingery, W. David. "Painterly Maiolica of the Italian Renaissance." *Technology and Culture* 34, no. 1 (January): 28–48.

KINGERY AND VANDIVER 1984
Kingery, W. David, and Pamela B. Vandiver. "Medici Porcelain." *Faenza* 70: 441–53.

KLEINMAN 1986
Kleinman, B. "History and Development of Early Islamic Pottery Glazes." In *Proceedings of the Twenty-fourth International Archaeometry Symposium*, ed. Jacqueline S. Olin and M. James Blackman, 73–84. Washington, D.C.

KOMAROFF AND CARBONI 2002
Komaroff, Linda, and Stefano Carboni. *The Legacy of Genghis Khan: Courtly Art and Culture in Western Asia, 1256–1353*, exh. cat. New York.

KRAHL 1986
Krahl, Regina, in collaboration with Nurdan Erbahar. *Chinese Ceramics in the Topkapi Saray Museum, Istanbul: A Complete Catalogue*, ed. John Ayers. Vol. 1, *Yuan and Ming Dynasty Celadon Wares*; vol. 2, *Yuan and Ming Dynasty Porcelains*; vol. 3, *Qing Dynasty Porcelains*. London.

KRÖGER 1998
Kröger, J. "Painting on Glass before the Mamluk Period." In *Gilded and Enamelled Glass from the Middle East*, ed. Rachel Ward, 8–11. London.

KRUEGER 1998
Krueger, Ingeborg. "An Enamelled Beaker from Stralsund: A Spectacular Find." In *Gilded and Enamelled Glass from the Middle East*, ed. Rachel Ward, 107–9. London.

KUHN 1957
Kuhn, Thomas. *The Copernican Revolution: Planetary Astronomy in the Development of Western Thought*. Cambridge, Mass.

KUHN 1962
Kuhn, Thomas. *The Structure of Scientific Revolutions*. Chicago.

LAMM 1929–30
Lamm, Carl Johann. *Mittelalterliche Gläser und Steinschnittarbeiten aus dem Nahen Osten*. 2 vols. Berlin.

LANE 1947A
Lane, Arthur. *Early Islamic Pottery: Mesopotamia, Egypt, and Persia*. London.

LANE 1947B
Lane, Arthur. "Sung Wares and the Seljuq Pottery of Persia." *Transactions of the Oriental Ceramic Society* 22: 19–30.

LANE 1954
Lane, Arthur. *Italian Porcelain, with a Note on Buen Retiro*. London.

LANE 1957
Lane, Arthur. *Later Islamic Pottery, Persia, Syria, Egypt, Turkey*. London.

LEHMANN 1977
Lehmann, Phyllis Williams. *Cyriacus of Ancona's Egyptian Visit and Its Reflections in Gentile Bellini and Hieronymous Bosch*. Locust Valley, N.Y.

LEVI DELLA VIDA 1939
Levi Della Vida, Giorgio. *Ricerche sulla formazione de più antico fondo dei manoscritti orientali della Biblioteca vaticana.* Rome.

LIEFKES 1997
Liefkes, Reino, ed. *Glass.* London.

LIGHTBOWN AND CAIGER-SMITH 1980
Lightbown, Ronald, and Alan Caiger-Smith, trans. *The Three Books of the Potter's Art / I tre libri dell'arte de vasaio: A Facsimile of the Manuscript in the Victoria and Albert Museum, London,* by Cipriano Piccolpasso. 2 vols. London.

LINDBERG 1992
Lindberg, David C. *The Beginnings of Western Science: The European Scientific Tradition in Philosophical, Religious, and Institutional Context, 600 B.C. to A.D. 1450.* Chicago.

LIVERANI 1936
Liverani, Giuseppe. *Catalogo delle porcellane dei Medici.* Faenza.

LORENZETTI 1920
Lorenzetti, Giulio. "Una fiaschetta veneziana de vetro 'lattimo' dei primi del secolo XVI." *Dedalo* 1: 248–49.

MACK 2002
Mack, Rosamond E. *Bazaar to Piazza: Islamic Trade and Italian Art, 1300–1600.* Berkeley.

MAGUIRE 1997
Maguire, Eunice Dauterman. "Ceramic Arts of Every-day Life." In *The Glory of Byzantium: Art and Culture of the Middle Byzantine Era, A.D. 843–1261,* exh. cat., ed. Helen C. Evans and William D. Wixom, 255–57. New York.

MALLET AND DREIER 1998
Mallet, J. V. G., and Franz Adrian Dreier. *The Hockemeyer Collection: Maiolica and Glass.* Bremen.

MARDRUS AND MATHERS 1972
Mardrus, J. C., and E. Powys Mathers, trans. *The Book of the Thousand Nights and One Night.* 4 vols. New York.

MASON AND TITE 1997
Mason, R. B., and Michael S. Tite. "The Beginnings of Tin-Opacification of Pottery Glazes." *Archaeometry* 39, no. 1: 46–48.

MASON, TITE, PAYNTER, ET AL. 2001
Mason, R. B., Michael S. Tite, S. Paynter, et al. "Advances in Polychrome Ceramics in the Islamic World of the Twelfth Century A.D." *Archaeometry* 43, no. 2: 191–209.

MASUYA 2000
Masuya, Tomoko Masuya. "Persian Tiles on European Walls: Collecting Ilkhanid Tiles in Nineteenth-Century Europe." *Ars Orientalis* 30: 39–53.

MATHEWS 1998
Mathews, Thomas F. *The Art of Byzantium: Between Antiquity and the Renaissance.* London.

MEDLEY 1974
Medley, Margaret. *Yüan Porcelain and Stoneware.* London.

MELIKIAN-CHIRVANI 1986
Melikian-Chirvani, A. S. "Silver in Islamic Iran." In *Pots and Pans: A Colloquium on Precious Metals and Ceramics in the Muslim, Chinese, and Graeco-Roman Worlds,* ed. Michael Vickers, 89–106. Oxford.

MESSISBURGO [1959] 1960
Messisburgo, Cristoforo. *Banchetti, composizioni di vivande, e apparecchio generale.* Reprint. Venice.

MEZZETTI 1965
Mezzetti, Amalia. *Il Dosso e Battista Ferraresi.* Milan.

MONBEIG GOGUEL 1998
Monbeig Goguel, Catherine, ed. *Francesco Salviati, 1510–1563, o la bella maniera,* exh. cat. Milan.

MONTANARI 1994
Montanari, Massimo. *The Culture of Food,* trans. Carl Ipsen. Oxford.

NALLINO 1911
Nallino, Carlo Alfonso. *Ilm al-Falak: Tarikhuhu inda al-Arab fi al-Qurun al-Wusta.* Rome.

NECIPOĞLU 1990
Necipoğlu, Gulru. "From International Timurid to Ottoman: A Change of Taste in Sixteenth-Century Tiles." *Muqarnas* 7: 136–70.

NECIPOĞLU 1991
Necipoğlu, Gulru. *Architecture, Ceremonial, and Power: The Topkapi Palace in the Fifteenth and Sixteenth Centuries.* Cambridge, Mass.

OSMA Y SCULL 1908
Osma y Scull, Guillermo Joaquín de. *Los maestros alfareros de Manises, Paterna, y Valencia: Contratos y ordenanzas de los siglos XIV, XV, y XVI.* Madrid.

OSMA Y SCULL 1912
Osma y Scull, Guillermo Joaquín de. *La loza dorada de Manises en el año 1454 (Cartas de la reina de Aragón á don Pedro Boil).* Madrid.

OTTAVIANI 1982
Ottaviani, Nico. *Statuto di Deruta in volgare dell'anno 1465.* Florence.

PEROSA 1960
Perosa, Alessandro, ed. *Giovanni Rucellai el il suo Zibaldone.* Pt. 1, "Il Zibaldone quaresimale," di G. Rucellai, pagina scelte. London.

PONTANO 1999
Pontano, Giovanni. *I libri delle virtù sociali,* ed. Francesco Tateo. Rome.

POPE 1956
Pope, E. M. "Ceramics: Medieval." In *A History of Technology*, by Charles Singer, pp. 284–310. Vol. 2, *The Mediterranean Civilizations and the Middle Ages, c. 700 B.C. to c. 1500 A.D.* Oxford.

PORTER 1981
Porter, Venetia. *Medieval Syrian Pottery (Raqqa Ware)*. Oxford.

PORTER 1995
Porter, Venetia. *Islamic Tiles*. London.

PORTER AND WATSON 1987
Porter, Venetia, and Oliver Watson. "'Tell Minis' Wares." In *Syria and Iran: Three Studies in Medieval Ceramics*, ed. James Allan and Caroline Roberts, 175–247. Oxford.

PRATER 1988
Prater, Andreas. *Cellinis Salzfass für Franz 1*. Stuttgart.

RABY 1991
Raby, Julian. "Picturing the Levant." In *Circa 1492: Art in the Age of Exploration*, exh. cat., ed. Jay A. Levenson, 77–81. Washington, D.C.

RACKHAM 1940
Rackham, Bernard. *Catalogue of Italian Maiolica [Victoria and Albert Museum]*. London.

RACKHAM 1944
Rackham, Bernard. "Italian Maiolica and China." *Transactions of the Oriental Ceramic Society, 1942–1943* 20: 9–20.

RAGEP 1993
Ragep, F. J., trans. *Nasir al-Din al-Tusi's Memoir on Astronomy/al-tadhkira fi ilm al-haya*. 2 vols. New York.

RAVANELLI GUIDOTTI 1995
Ravanelli Guidotti, Carmen. "'Prove' di lustro a Faenza." *CeramicAntica* 5, no. 5: 38–47.

RAY 2000
Ray, Anthony. *Spanish Pottery, 1248–1898: With a Catalogue of the Collection in the Victoria and Albert Museum*. London.

REID 1992
Reid, Donald M. "Cultural Imperialism and Nationalism: The Struggle to Define and Control the Heritage of Arab Art in Egypt." *International Journal of Middle East Studies* 24 (1992): 57–76.

RIIS AND POULSEN 1957
Riis, Poul J., and Vagn Poulsen. *Les verreries et poteries médiévales*. Copenhagen.

ROGERS 1991
Rogers, J. Michael. "'Terra di Salonich, Simile a la porcellana': Some Problems in the Identification and Attribution of Earlier Sixteenth-Century Iznik Blue and White." In *Italian Renaissance Pottery: Papers Written in Association with a Colloquium at the British Museum*, ed. Timothy Wilson, 253–60. London.

ROGERS 2002
Rogers, J. Michael. "Europe and the Ottoman Arts: Foreign Demand and Ottoman Consumption." In *Europe and Islam between the Fourteenth and Sixteenth Centuries*, eds. Michele Bernardini, Clara Borrelli, Anna Cerbo, and Encaración Sánchez García, 709–36. Naples.

SARRE 1925
Sarre, Friedrich. *Die Keramik von Samarra*. Berlin.

SCANLON 1970
Scanlon, George T. "Egypt and China: Trade and Imitation." In *Islam and the Trade of Asia: A Colloquium*, ed. Donald Sidney Richards, 81–95. Oxford.

SCANLON 1998
Scanlon, George T. "Lamm's Classification and Archaeology." In *Gilded and Enamelled Glass from the Middle East*, ed. Rachel Ward, 27–29. London.

SCHMIDT 1922
Schmidt, Robert. *Das Glas*. Berlin.

SCHUSTER 1993
Schuster, Bettina. *Meissen: Geschichten zur Geschichte und Gegenwart der ältesten Porzallanmanufaktur Europas*. Vienna.

SOUCEK 1997
Soucek, Priscilla. "Byzantium and the Islamic East." In *The Glory of Byzantium: Art and Culture of the Middle Byzantine Era, A.D. 843–1261*, exh. cat., ed. Helen C. Evans and William D. Wixom, 403–11. New York.

SPALLANZANI 1978
Spallanzani, Marco. *Ceramiche orientali a Firenze nel Rinascimento*. Florence.

SPALLANZANI 1989
Spallanzani, Marco. "Fonti archivistiche per lo studio dei rapporti fra l'Italia e l'Islam: Le arti minori nei secoli XIV– XVI." In *Arte veneziana e arte islamica: Atti del primo simposio internazionale sull'arte veneziana e l'arte islamica*, ed. Ernst J. Grube, 83–100. Venice.

SPALLANZANI 2002
Spallanzani, Marco. "Maioliche ispano-moresche a Firenze nei secoli XIV–XV." In *Economia e arte secc. XIII–XVIII: Atti della 'Trentatreesima settimana di studi,'* ed. Simone Cavaciocchi, 367–77. Florence.

SUFI 1962
Sufi, Abd al-Rahman al-. *Kitab al-amal bi-l-Asturlab*. Introduction by E. S. Kennedy and Marcel Destombes. Hyderabad.

TAIT 1991
Tait, Hugo, ed. *Glass, Five Thousand Years*. London.

TAIT 1998
Tait, Hugo. "The Palmer Cup and Related Glasses Exported to Europe in the Middle Ages." In *Gilded and Enamelled Glass from the Middle East*, ed. Rachel Ward, 50–55. London.

TAIT 1999
Tait, Hugh. "Venice: Heir to the Glassmakers of Islam or Byzantium?" In *Islam and the Italian Renaissance*, ed. Charles Burnett and Anna Contadini, 77–104. London.

TILL 1992
Till, Barry, with Paula Swart. *The Blue and White Porcelain of China*. Victoria, B.C.

TITE, FREESTONE, MASON, ET AL. 1998
Tite, Michael S., I. Freestone, R. B. Mason, et al. "Lead Glazes in Antiquity: Methods of Production and Reasons for Use." *Archaeometry* 40, no. 2: 241–58.

TOOMER 1996
Toomer, G. J. *Easterne Wisdome and Learning: The Study of Arabic in Seventeenth-Century England*. Oxford.

TURNER 1985
Turner, A. J. *The Time Museum: Time Measuring Instruments: Astrolabes and Astrolabe Related Instruments*. Rockford, Ill.

UDOVITCH 1993
Udovitch, Abraham L. "Market and Society in the Medieval Islamic World." In *Mercati e mercanti nell'alto medioevo: L'area euroasiatica e l'area Mediterranea*, 767–90. Spoleto.

VALERI 1984
Valeri, Anna Moore. "Florentine 'Zaffera a Rilievo' Maiolica: A New Look at the 'Oriental Influence.'" *Archeologia medievale* 11: 477–500.

VERITÀ 1984
Verità, Marco. "Analyses of Early Enamelled Venetian Glass." In *Gilded and Enamelled Glass from the Middle East*, ed. Rachel Ward, 129–34. London.

VERNOIT 1996
Vernoit, Stephen. "Murdoch Smith, Sir Robert." In *The Dictionary of Art*, ed. Jane Turner, 22: 340. New York.

VERNOIT 1998
Vernoit, Stephen. "Islamic Gilded and Enamelled Glass in Nineteenth-Century Collections." In *Gilded and Enamelled Glass from the Middle East*, ed. Rachel Ward, 110–15. London.

VITALI 1990
Vitali, Marcella. "Le influenze della ceramic islamica sulla maiolica italiana." In *Le mille e una notte: Ceramiche persiane, turche, e ispano moresche*, exh. cat., 249–53. Faenza.

WALLIS 1894
Wallis, Henry. Introduction to *The Godman Collection: Persian Ceramic Art Belonging to Mr. F. DuCane Godman, F.R.S. with Examples from Other Collections: The Thirteenth-Century Lustred Wall-Tiles*. London.

WALLIS 1900
Wallis, Henry. *The Oriental Influence on the Ceramic Art of the Italian Renaissance*. London.

WARD 1998
Ward, Rachel. "Glass and Brass: Parallels and Puzzles." In *Gilded and Enamelled Glass from the Middle East*, ed. Rachel Ward, 30–34. London.

WATSON 1985
Watson, Oliver. *Persian Lustre Ware*. London.

WATSON 1998
Watson, Oliver. "Pottery and Glass: Lustre and Enamel." In *Gilded and Enamelled Glass from the Middle East*, ed. Rachel Ward, 15–19. London.

WEILL 1987
Weill, Georges. *Vie et caractère de Guillaume Postel*, trans. François Secret. Milan.

WHITEHOUSE 1969
Whitehouse, David. "Excavations at Siraf: Second Interim Report." *Iran* 7: 39–62.

WHITEHOUSE 1971
Whitehouse, David. "La liguria e la ceramica medievale nel Mediterraneo." In *Atti del IV Convegno internazionale della ceramica*, 263–94. Albisola.

WHITEHOUSE 1972
Whitehouse, David. "Excavations at Siraf: Fifth Interim Report." *Iran* 10: 63–87.

WHITEHOUSE 1978
Whitehouse, David. "The Origins of Italian Maiolica." *Archaeology* 31, no. 2 (March–April): 42–49.

WHITEHOUSE 1980
Whitehouse, David. "Proto-Maiolica." *Faenza* 66, no. 1/6: 77–83.

WHITEHOUSE 1998
Whitehouse, David. "Byzantine Gilded Glass." In *Gilded and Enamelled Glass from the Middle East*, ed. Rachel Ward, 4–7. London.

WIET 1929
Wiet, Gaston. *Catalogues générals du Musée arabe du Caire*. Cairo.

WILLIAMS 1993
Williams, Caroline. *Islamic Monuments in Cairo*. Fourth ed. Cairo.

WILSON 1984
Wilson, Timothy. "Some Medici Devices on Pottery." *Faenza* 70: 433–40.

WILSON 1996
Wilson, Timothy. "The Beginnings of Luster-Ware in Renaissance Italy." In *The International Ceramics Fair and Seminar Handbook*, 35–43. London.

YEO AND MARTIN 1978
Yeo, S. T., and Jean Martin, comps. *Chinese Blue and White Ceramics*. Singapore.

Index

NOTE: Page numbers in *italics* indicate illustrations.